Fantasy Art Drawing For Beginners

Drawing Fantasy Creatures With Simple Instructions

By Emily Ricker

Copyright©2016 by Emily Ricker

All Rights Reserved

Copyright © 2016 by Emily Ricker

All rights reserved. No part of this publication may be reproduced, distributed, or transmitted in any form or by any means, including photocopying, recording, or other electronic or mechanical methods, without the prior written permission of the author, except in the case of brief quotations embodied in critical reviews and certain other noncommercial uses permitted by copyright law.

Table of Contents

Introduction	5
Chapter 1 – How to Draw a Griffin?	11
Chapter 2 – How to Draw the Eye of a Scary Mythical Creature?	18
Chapter 3 – How to Draw an Elf?	27
Chapter 4 – How to Draw a Mermaid?	36
Chapter 5 – How to Draw a Gnome?	41
Chapter 6 – How to Draw a Lady Centaur?	47
Conclusion	54

Disclaimer

While all attempts have been made to verify the information provided in this book, the author does assume any responsibility for errors, omissions, or contrary interpretations of the subject matter contained within. The information provided in this book is for educational and entertainment purposes only. The reader is responsible for his or her own actions and the author does not accept any responsibilities for any liabilities or damages, real or perceived, resulting from the use of this information.

The trademarks that are used are without any consent, and the publication of the trademark is without permission or backing by the trademark owner. All trademarks and brands within this book are for clarifying purposes only and are the owned by the owners themselves, not affiliated with this document.

Introduction

Since humans began to engage in art, one thing became absolutely clear - there are people who can effortlessly sketch an object and there are those who toil for hours to draw the right angles and proportions to the extent that their drawing gets ruined.

Drawing is a great hobby, but it can be more than that. As a hobby, drawing offers a lot of pleasure and every moment of drawing will fill you with joy. As a hobby, drawing needs only the basic tools and does not cost much. Drawing can be more than a hobby - it may be the answer to the question of how to earn extra money.

What distinguishes artists from non-artists?

Recent studies reveal the answer to this question which was first asked a long time ago. It seems that the ability of realistic drawing depends on several things, including the way in which a person experiences the reality.

If you are stuck at drawing figure, according to researchers from the University of London, good news is that all these mental processes can

improve with practice. Firstly, people who cannot draw do not see the world as it really is. When we see an object, our visual system automatically misjudges attributes such as size, shape and color, so some of the misinterpretations become mistakes in drawing.

Paradoxically, in some other situations, the misinterpretation will help us to feel like everything makes sense. For example, the building looks bigger when it is near than when it is far away. Even then, the visual system uses a "constant size" to perceive an approximate size, regardless of how the object is located. The visual system "knows" that the distant object is larger than it looks and the brain sends false information about what eyes are actually seeing.

"However, the wrong perception of the image is only part of the story," said psychologist Rebecca Chamberlain of the University of London. She and her colleagues conducted experiments investigating the role of memory in the process of drawing.

They believe that the skills of drawing in part the result of memory abilities of simple relationships between objects, such as the angle between two lines, from the moment of perceiving the angle until the moment they start

drawing. They came to a conclusion that the ability to change the way of looking at things is a good foundation for being successful at any kind of art.

That means that the only problem that stands in your way to becoming great in drawing interesting pictures can be solved easily. You just need to open your mind and try hard. Still, to make the things even easier for you, we explained how to draw simple drawings of mythical creatures in this book, in step by step guides.

According to the researcher, every component of successful drawing technique can be taught. Chamberlain adds that there are some people with natural ability for beautiful drawing. But, there aren't many of those with such talent. A huge majority of people need to learn how to draw beautiful pictures.

However, the problem is in the details, so researchers continue to work on the interaction of all the factors affecting the accuracy of drawing. However, they can also learn. "There is no doubt that exercise is an important component skill of drawing," says Chamberlain. "While some have

predispositions for better perceptual accuracy and visual memory, others can use tricks to mimic it."

In a study presented a few years ago at the Columbia University, Chamberlain has revealed that practice significantly improves the ability of drawing during the time, which was seen in people who took part in the survey.

Based on these studies, psychologists recommend the following techniques to draw better: focusing on scale drawings to fit on the paper size; ensuring that the object is placed in your environment to the appropriate place in space; to the focus on the distance between the elements of the subject and their relative size; to the focus on the size and shape of the "negative space", i.e. the empty space between the parts of the building. Finally, they recommend thinking about the lines in the way they really are – the lines are actually the border between light and dark areas.

Kris McManus, a member of the research team points out: "There aren't many skills that a person can't improve with practice."

We realized that plain practice without guidelines is fruitless. That's why we decided to write the book in the first place. Once you know exactly what you need to draw and how, you will not spend too much time trying and failing to draw an awesome drawing.

But, practice drawing can sometimes be boring. That is not the case if you decide on drawing interesting objects and creatures. If you've always been a fan of fiction and legends, your choice should be drawing mythical creatures. You can relive your childhood and let your imagination loose, drawing all sorts of scary monsters and fairies. Make your own fairytale or stick to the most famous epic stories.

If you are not already a fan of mythical creatures, you should keep on reading the book as there you can read the stories of griffins, elves, dragons, mermaids, gnomes and centaurs, which will make you fall in love with these fantasy creatures. Hopefully, the myths about these beings will spark your imagination and help you come up with fictional universe of your own.

So, there is nothing that is stopping you from learning to draw fantasy creatures right away. The only thing you need is a piece of paper and a pen.

Surely, before starting to draw, you first need to read this eBook. Finally, have one thing in mind – there's not book that can help you learn to draw amazing fantasy creatures if you don't have the will to do it.

Chapter 1 – How to Draw a Griffin?

Griffin is a mythological beast with the body of a lion and the head of an eagle. The lion used to be considered the king of the animals in the ancient times, while the eagle was the king of the sky for many of the ancient civilizations. As the combination of the two animals, griffin became an important mythical creature, both powerful and magical.

It is a common fallacy that the ancient Greeks invented this creature. They did make it very popular, for which there are hundreds of thousands of proofs. However, the Greeks didn't come up with the concept of lion-eagle in the first place, but Scythians. This nomadic people rode horses all over the world and once they come from Asia to Europe, they brought their culture and legends with them. The Greeks loved many of those, particularly the myth of the griffin, which later became one of the pillars of the Ancient Greek mythology.

The myth of Griffins was born in the areas of Assyria, Persia (present day Iran), and Phoenicia. The archaeological discoveries in the late 19th and early 20th century, led to the discovery of the majestic ancient cities in these areas: Uruk, Babylon, Nineveh, Nimrud and many others close to the

Euphrates and Tigris River (Mesopotamia), the Persian Gulf, etc. All of these areas are now parts of Iran, Iraq and the surrounding countries.

The first findings were fascinating and simply pressured the archeologist Henry H. Layard and others to investigate further and further. The first statues of griffins that they saw were, unfortunately, simply disintegrated! Some of them lay under layers of sand, earth and diverse material for ages. Still, due to a high number of griffin sculptures, many of them were intact. Most of those can nowadays been in many history museums around the world.

Griffins have been the source of inspiration for many artists for dozens of centuries. The symbol was used for the coat of arms of royal families, emblems of armies, etc. These days, many sport teams use it for their mascot, like the ice hockey team, Grand Rapids Griffins or the football club Suwon Samsung Blue wings.

If you also find griffins fascinating, you should learn how to draw them. And the best way for that is to simply follow our instructions.

The step one is to draw three circles, which would later become the griffin's head front body and the back.

Draw griffin's legs and head.

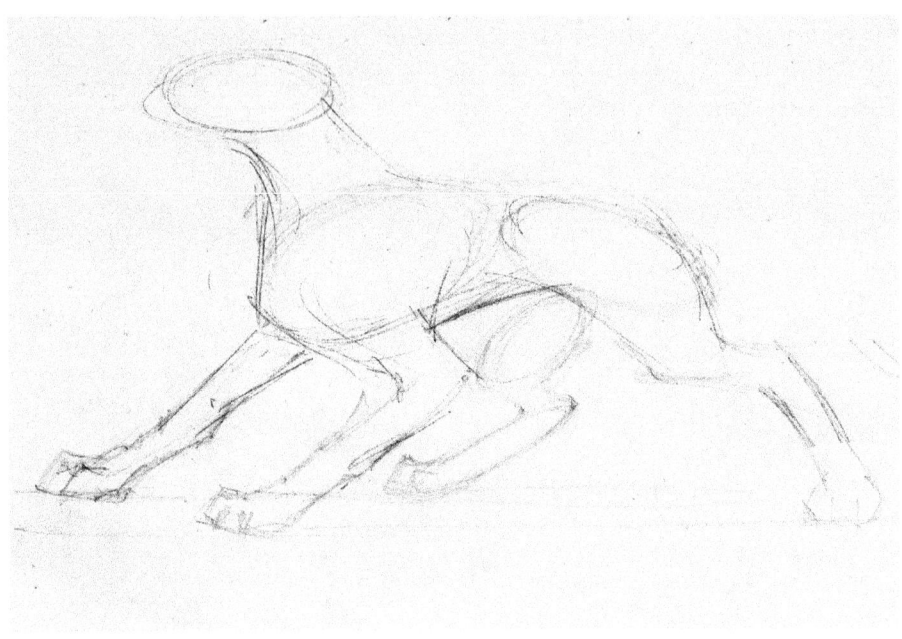

Bold the lines making the contour of the griffin's legs, head, back and tail.

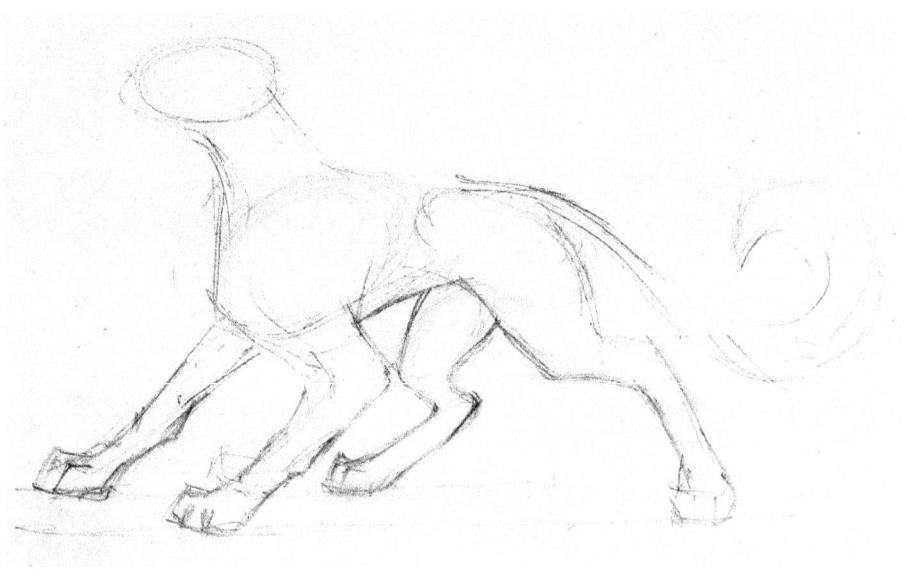

Finish the tail and start drawing feathers bellow the head of the griffin.

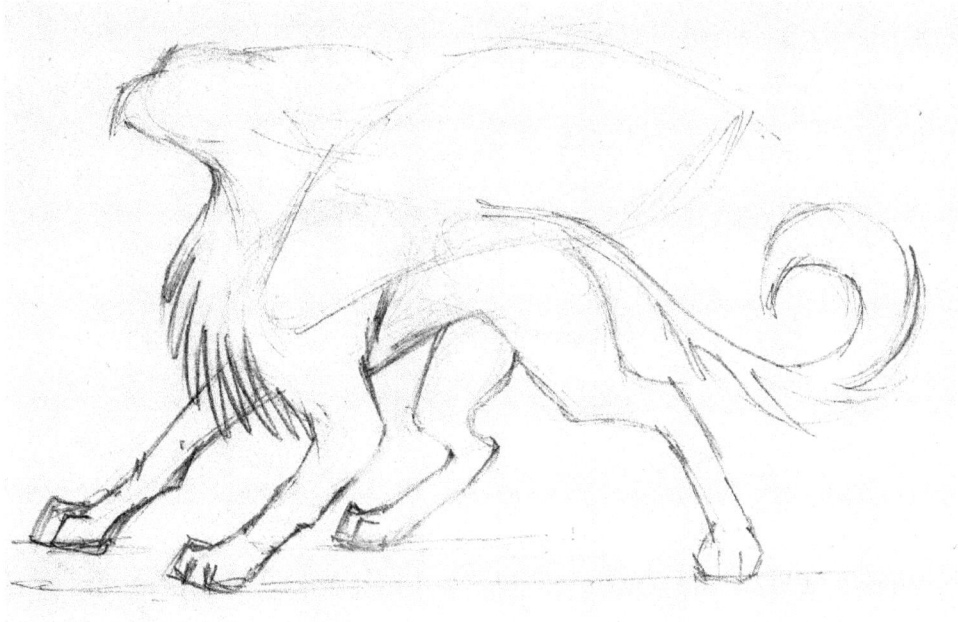

Now finish drawing the head of the griffin, which is actually the head of a bird. Also, draw the wings in this step, as well.

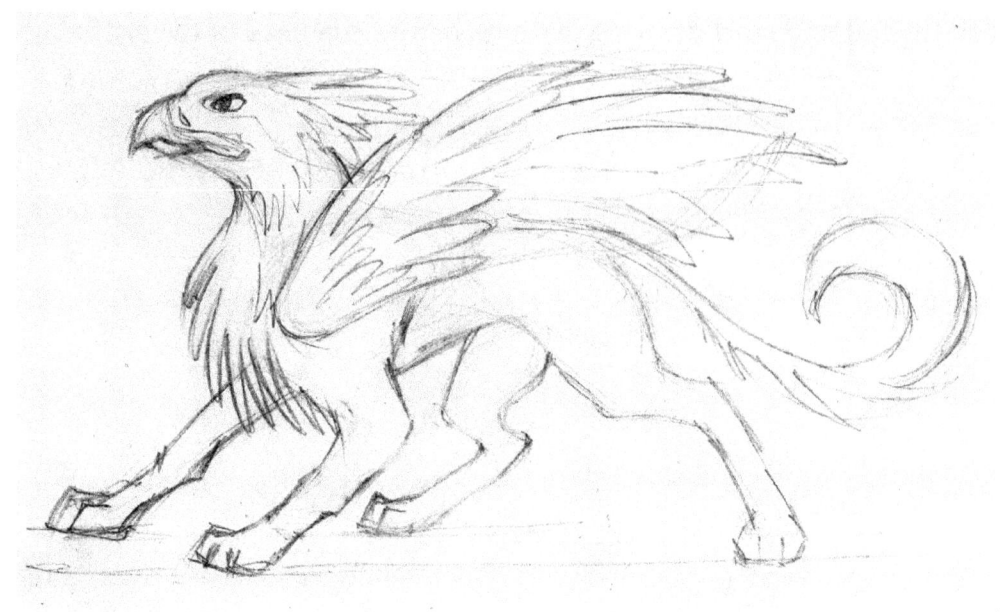

Add more details to the griffin's body and face, like beak, feathers and the wings.

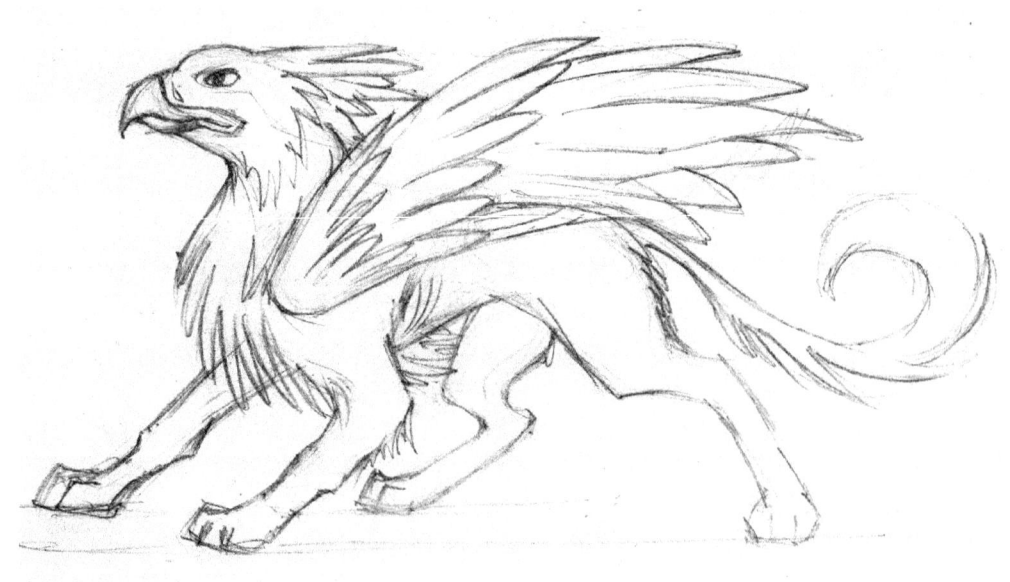

Finally, make bold all of the lines of the griffin, while deleting those you don't find to belong there. The final version of the griffon looks like something that could be used on coat of arms of medieval knights. But, if you wish, you can make the creature look more benign or just the opposite, scarier. The sky is the limit – feel free to unleash your imagination.

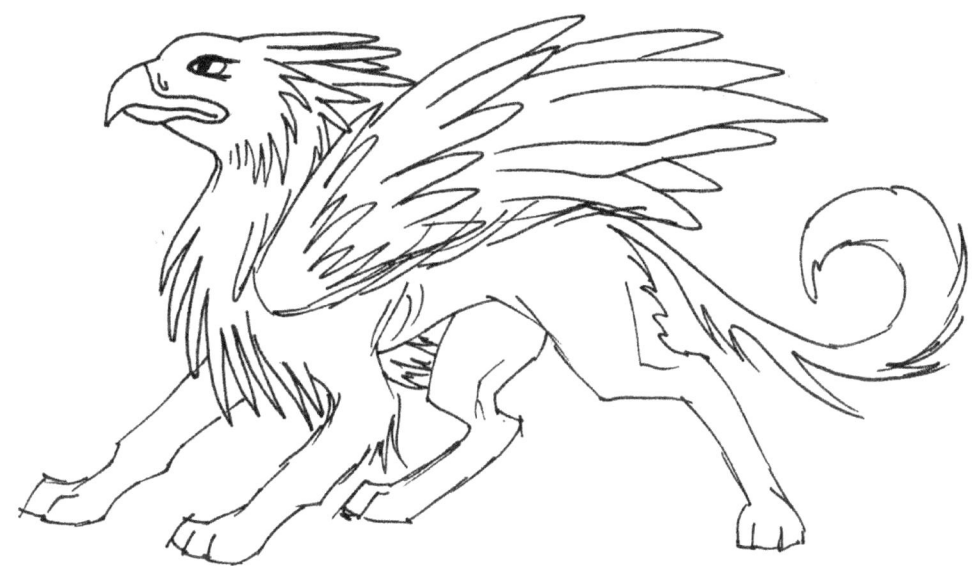

Chapter 2 – How to Draw the Eye of a Scary Mythical Creature?

Dragon is a mythical creature, reminiscent of a giant scary reptile. An interesting thing about this beast is that it has been featured as a part of many different ancient cultures, from all around the world. Dragons were part of ancient Chinese, Indian and Japanese culture, but also were inspiring ancient artists from Europe and North Africa.

In fact, all depictions of dragons can be separated into two distinctive groups, European and Chinese. The European dragon comes probably from the Ancient Greece, who transformed many different myths of Middle Eastern people into one. The name "dragon" literary translates from Greek as large water snake.

Actually, in the ancient times, dragons were almost exclusively depicted as big serpents. The idea about dragons being lizard-like creatures comes from the Middle Ages. The modern depiction of a dragon is a big scary reptile with a pair or two pair of legs, bet-like wings and ability to spit fire.

The inspiration for the later feature of the dragon most likely comes from cobras, which are able to spit poison, in the same manner the dragon spits fire. What made people think about dragons in the first place might be the evidence of dinosaurs or found skeletons of large crocodiles and whales. Actually, in 300 BC, a dinosaur skeleton was discovered in China, but people believed it to be a skeleton of a dragon.

Dragons have always been inspiration for artists. In the Middle Ages, dragons were symbol for strength and bravery. In fact, the real Count Dracula was a member of the Dragon society and had this symbol on his crest. Even his name comes from this creature – Dracula means dragon in Romanian.

If you're looking to be one of the millions of people who have been drawing dragons, pay close attention to what comes next. We are going to shows you the easiest way to draw the eye of a dragon, or in fact, any other scary mythical beast.

Start simply by drawing a rectangle shaped contour of the creature's eye.

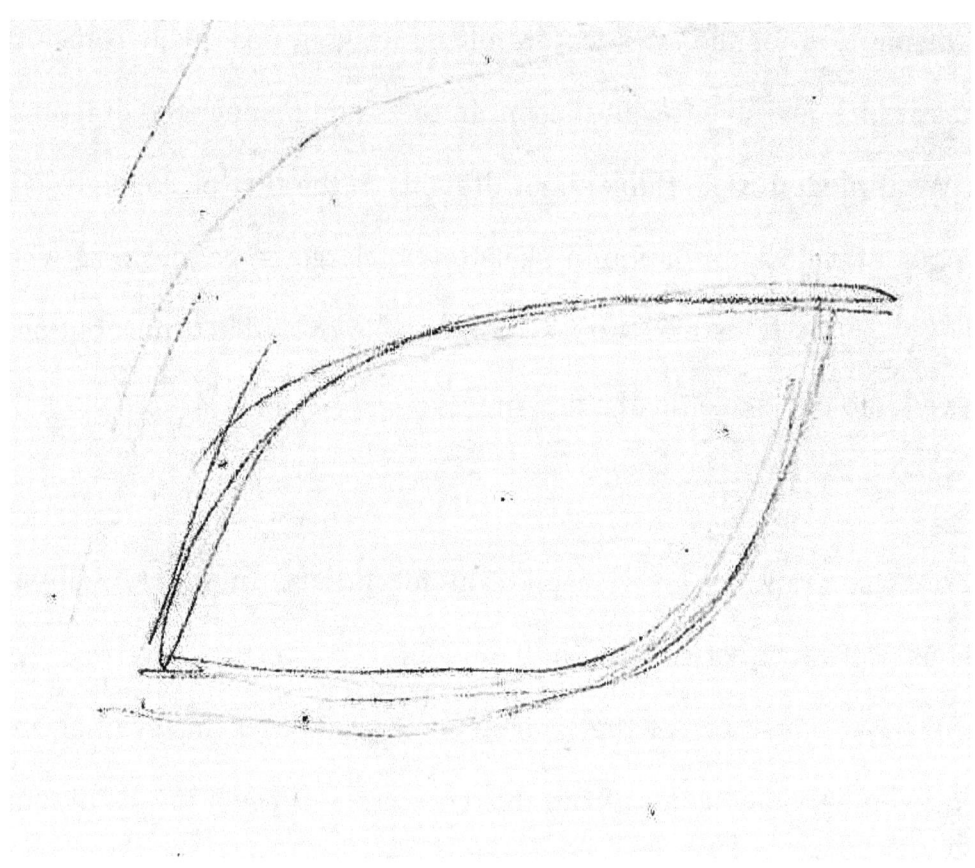

Follow the eye line, drawing two leaf-like objects, one above, the other below.

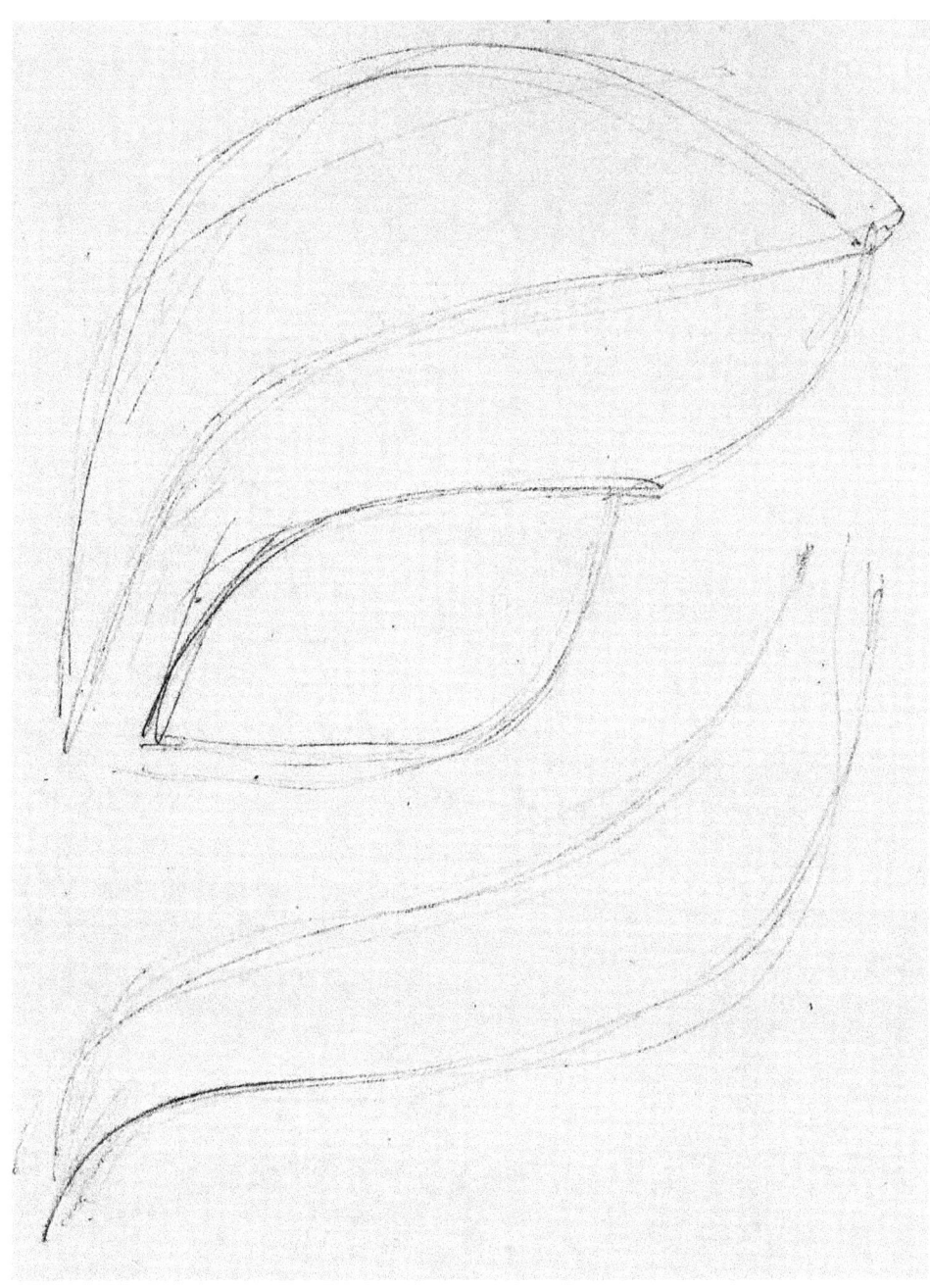

Draw the pupil of the eyes, as well as the eyelashes of the mythical creature.

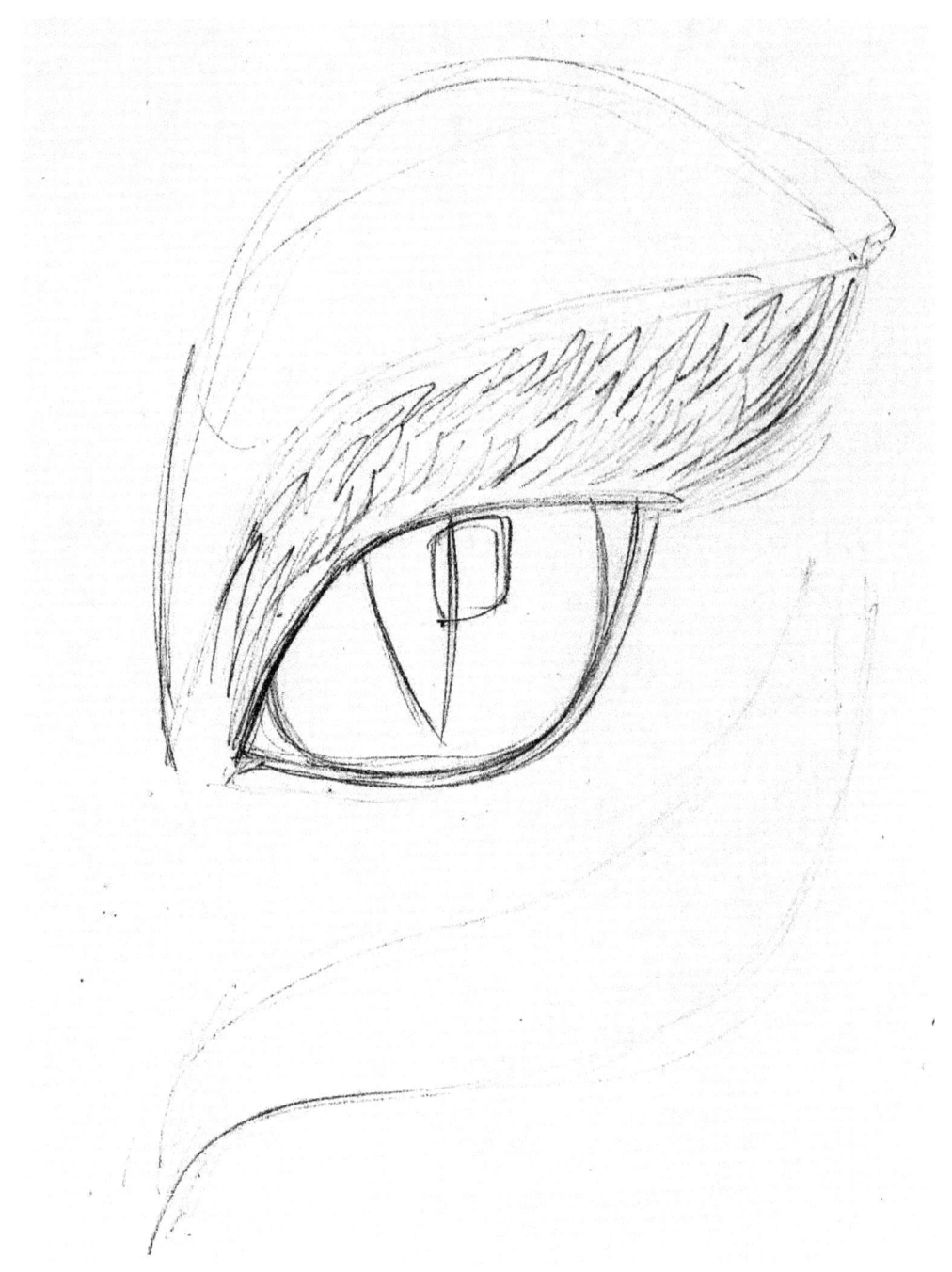

Add more eyelashes, which should be drawn to look like sherds.

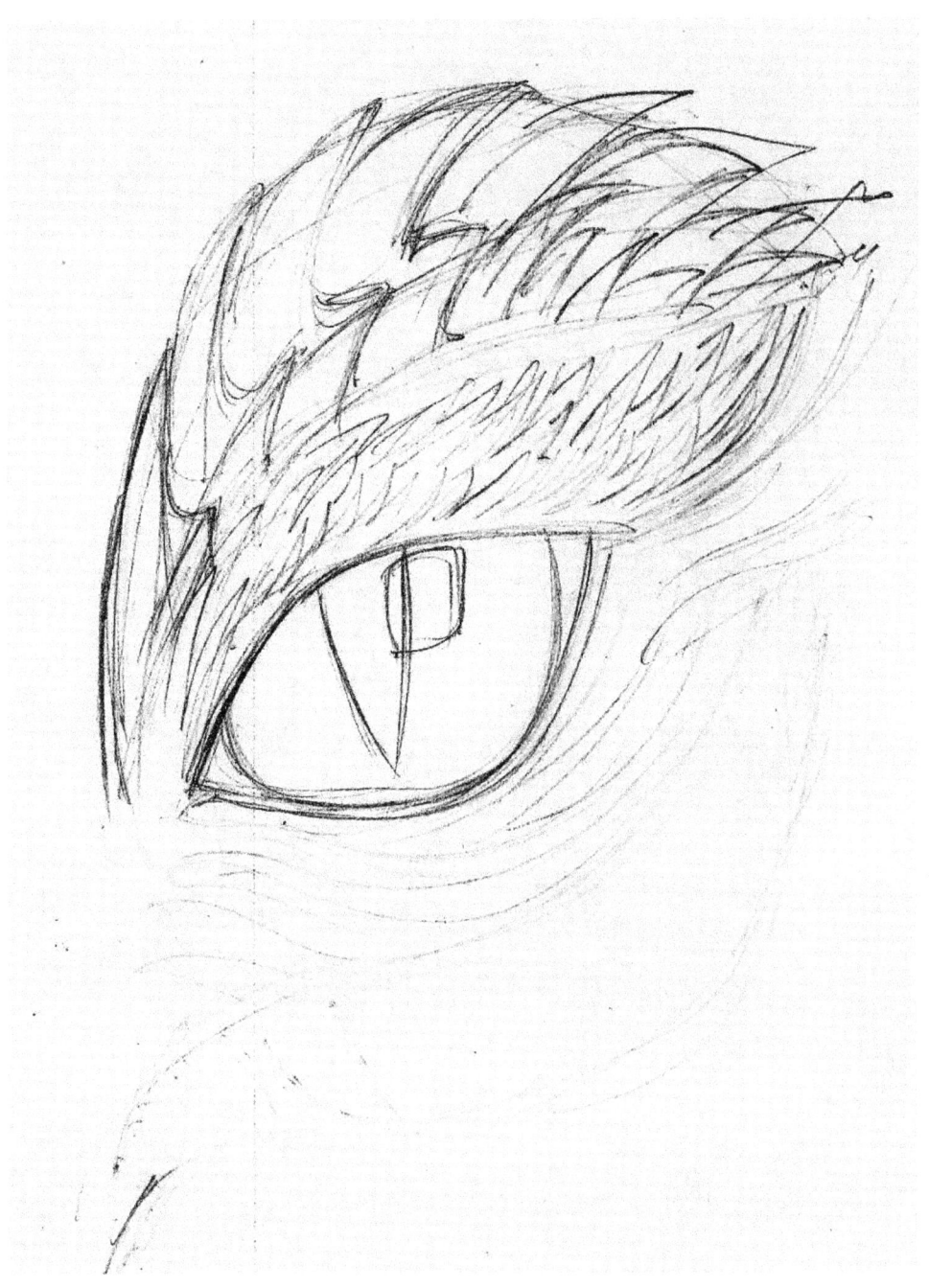

Finish both lower and upper eyelashes.

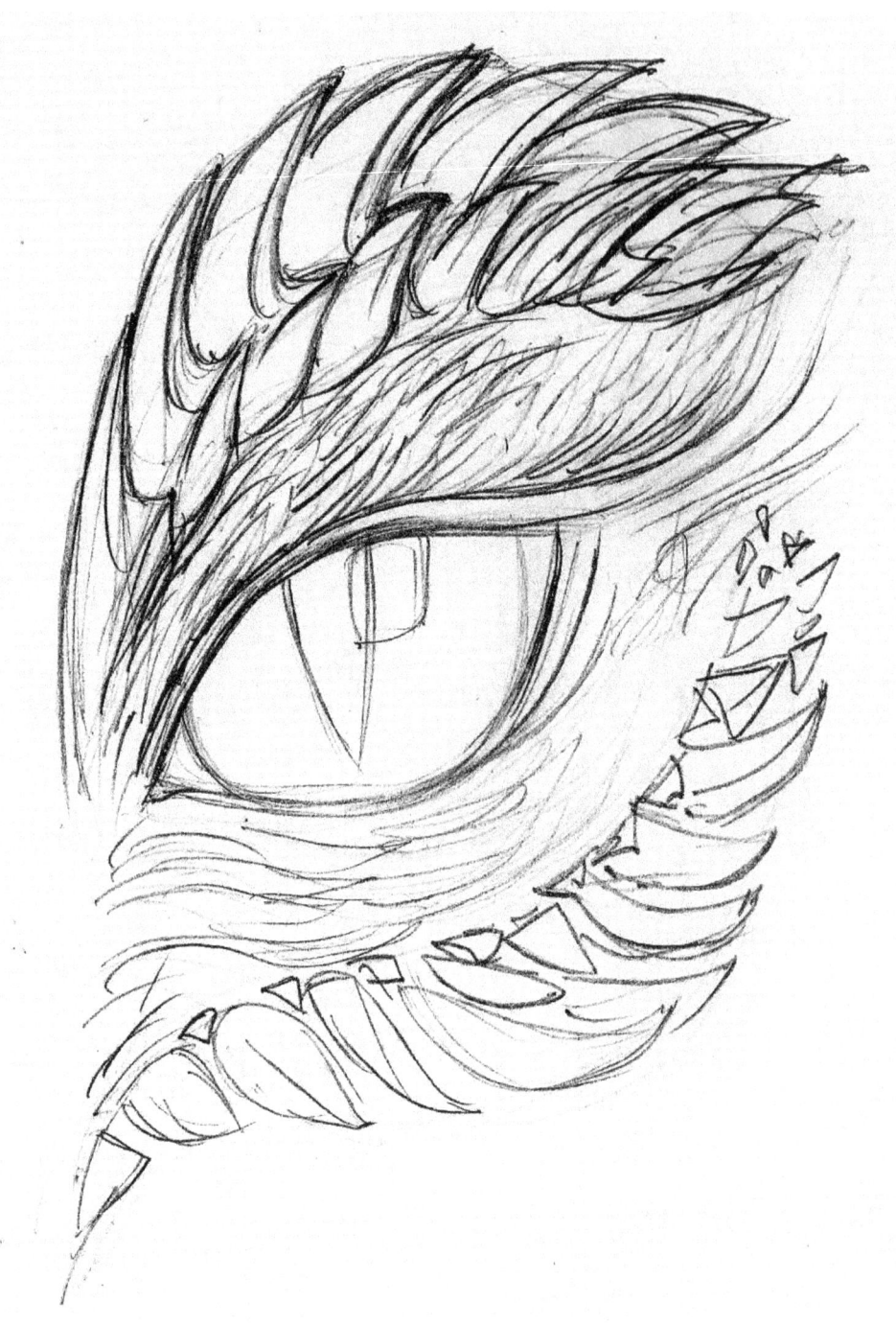

Erase the lines you don't find to look nice and make other lines bold, before finishing.

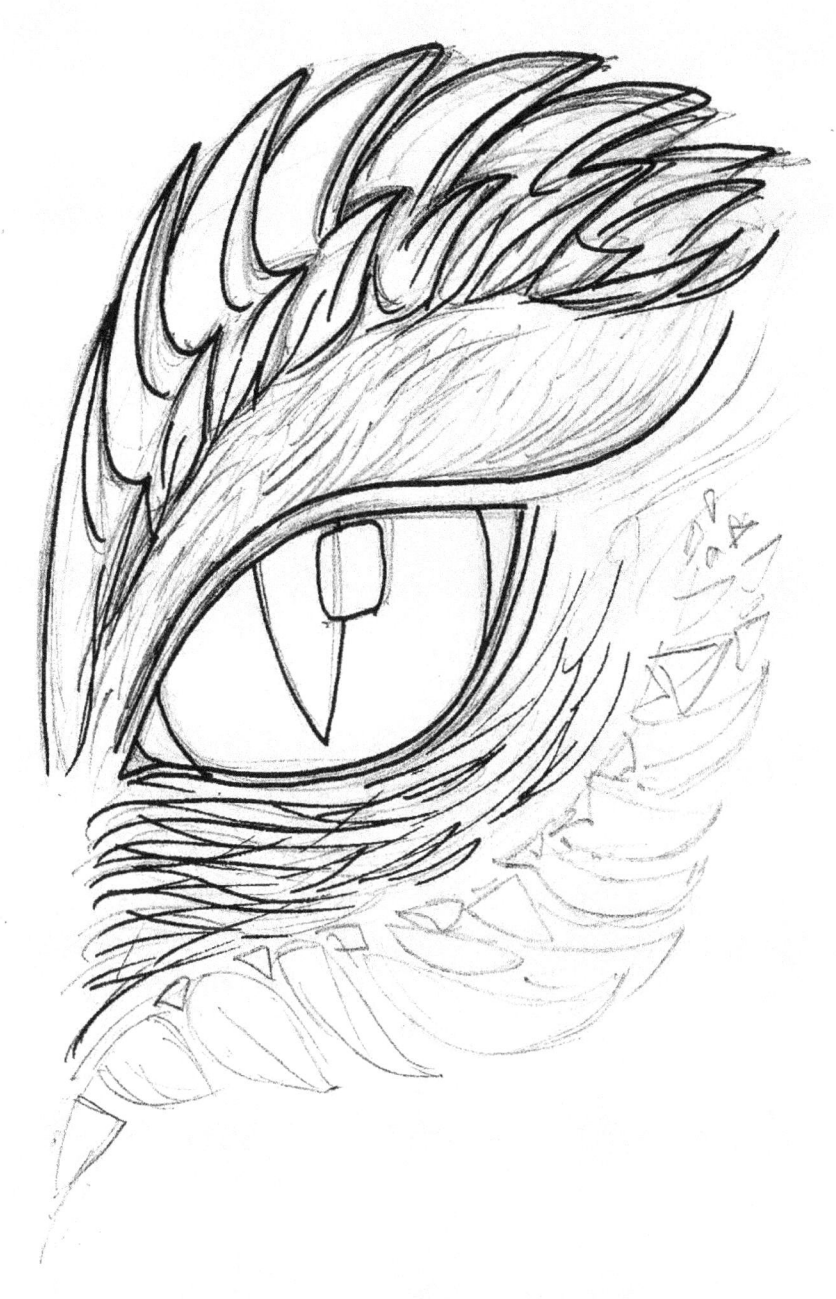

This is how the final version of the drawing should look like. It should appear vicious with the pupil of a reptile that's looking to catch a prey. Of course, feel creative and add a personal touch to the drawing.

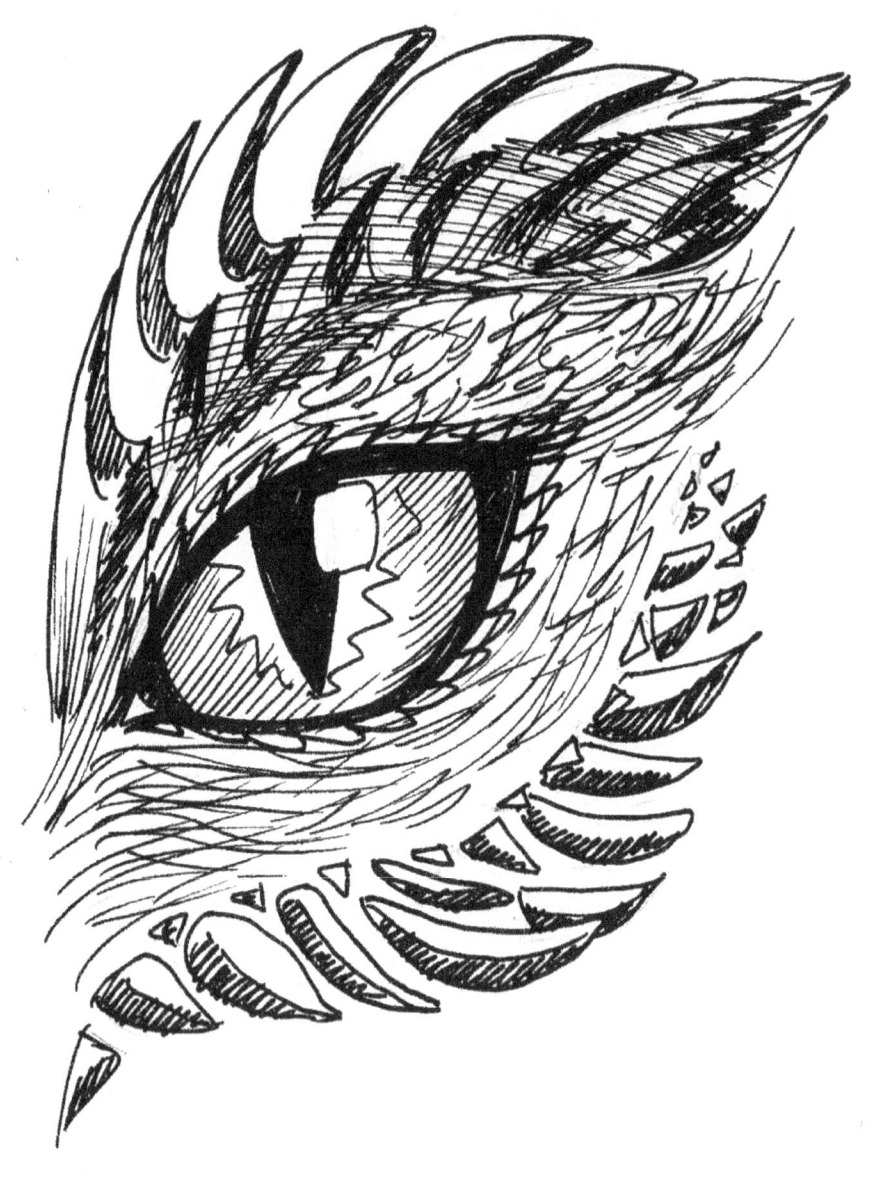

Chapter 3 – How to Draw an Elf?

Unlike the previous two entries, elves are not scary – they're the good guys. The elves are mythical creatures that bring people luck. Celtic people relate them to happiness. It's believed that the elf came from the dragon Hydra, who eats nothing but shamrock. An elf is born every time a person finds a four-leaf clover.

Apart from Celtic version, there is also the Germanic elf. These elves are the most beautiful creatures in the world and are mentioned in hundreds of stories from the Middle Ages.

The elf is a human size creature, with no beards or mustaches. The only physical trait that makes elves distinguishable from humans are their long pointy ears. The elves from the works of J.R.R. Tolkien, like The Lord of the Rings, for example, are immortal beings that have close connection to nature.

Learning to draw elves, means learning to draw beautiful people. You can use these skills in the future for drawing the portraits of your friends and

family. Of course, do not forget to do different kinds of ears! So, here is how it goes.

First draw the contour of the elf's head, which should be just a simple circle-like object.

Start bolding the lines, adding elements to create the nose and the lips.

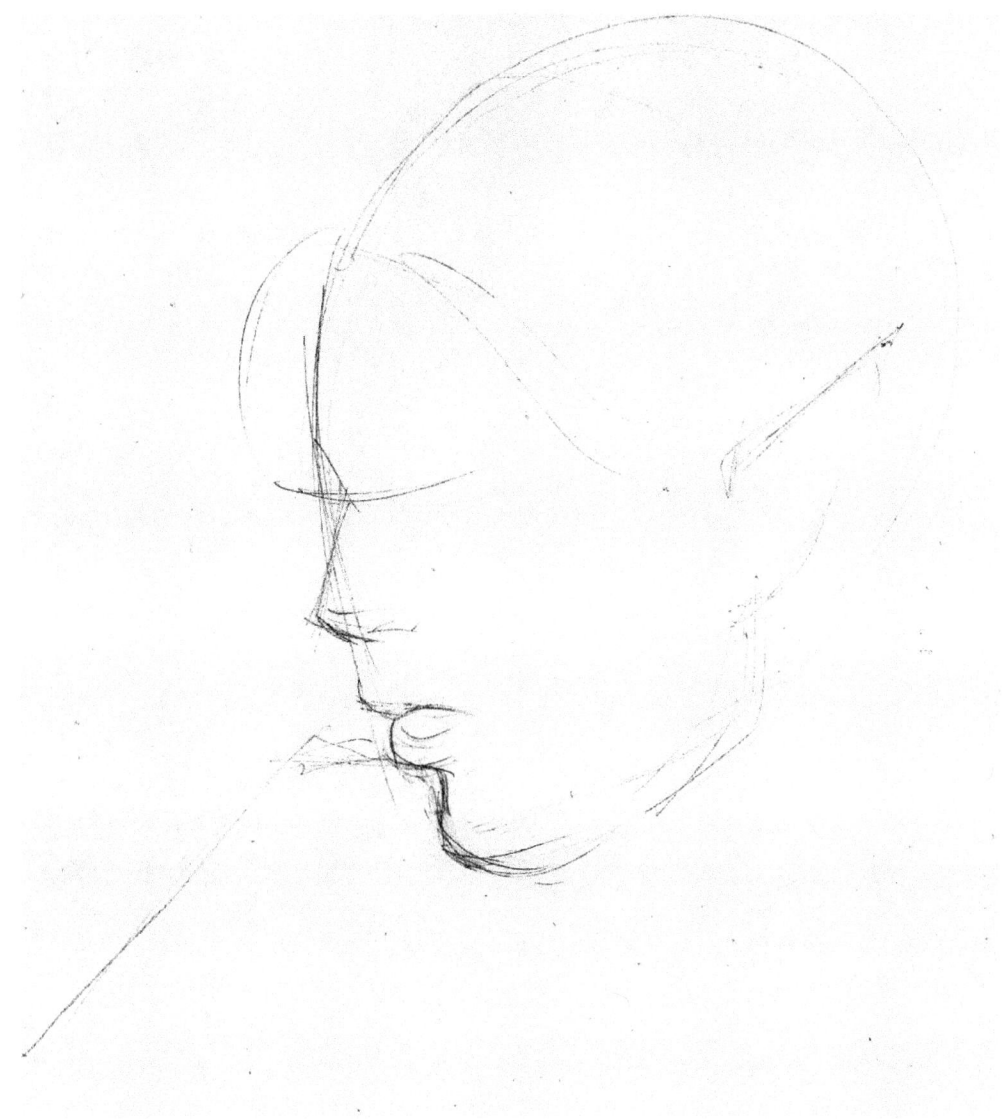

The next step is to make lines thicker and add details such as eyelashes.

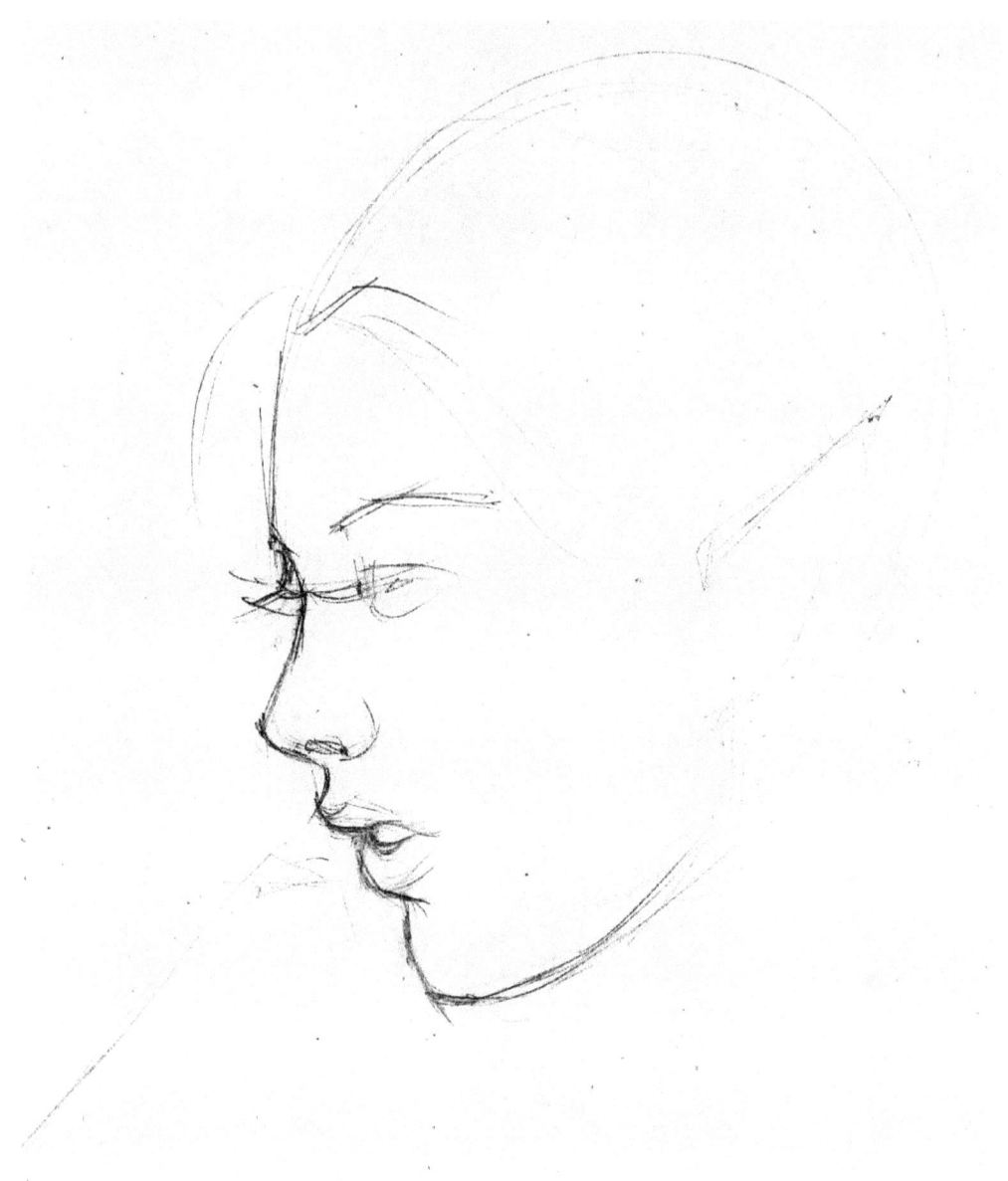

Draw the tiara and the pointy ears of the elf.

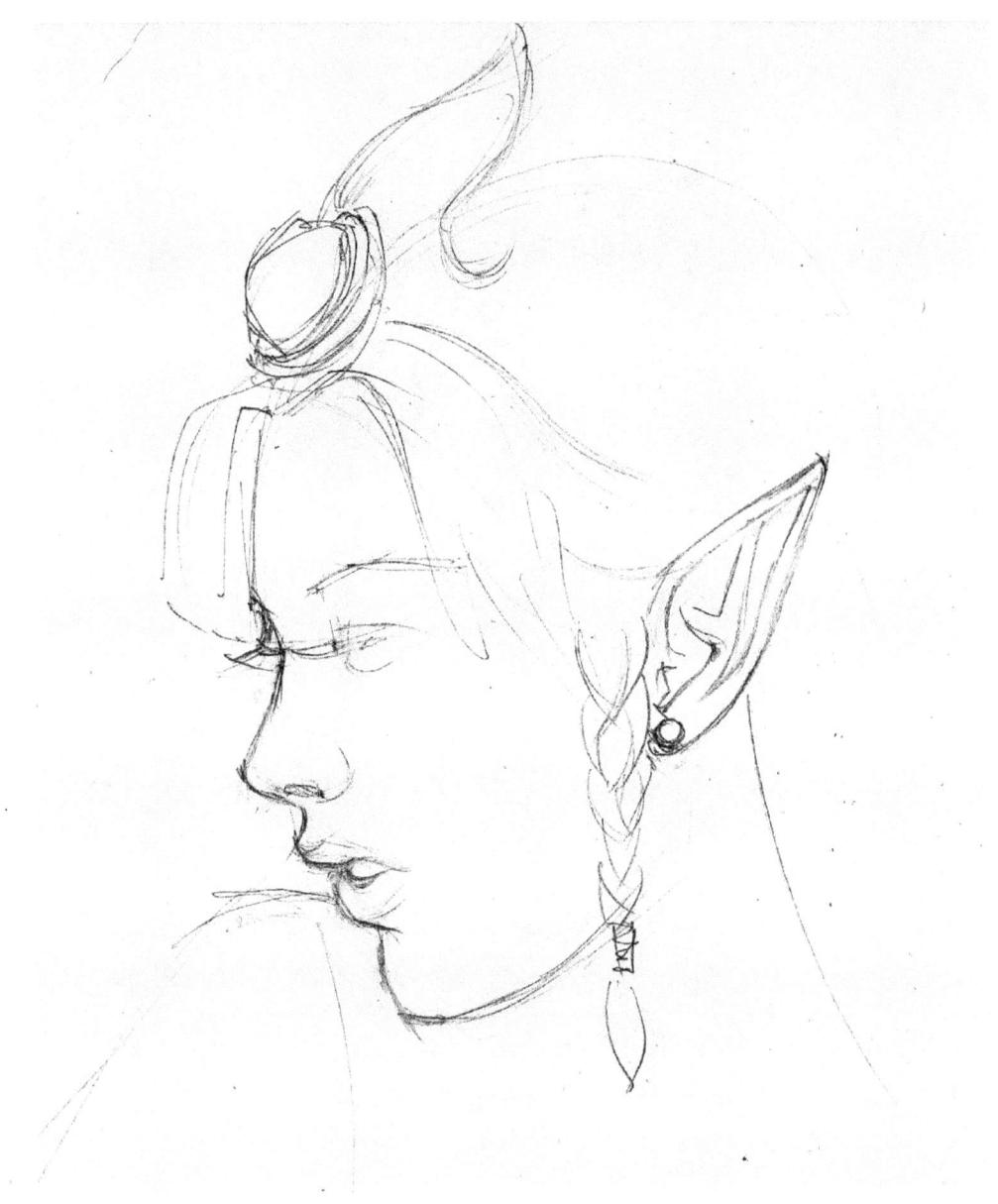

Now it's time to add more details, drawing hair and finishing with the face features. At this point, you should see that an elf is on the drawing.

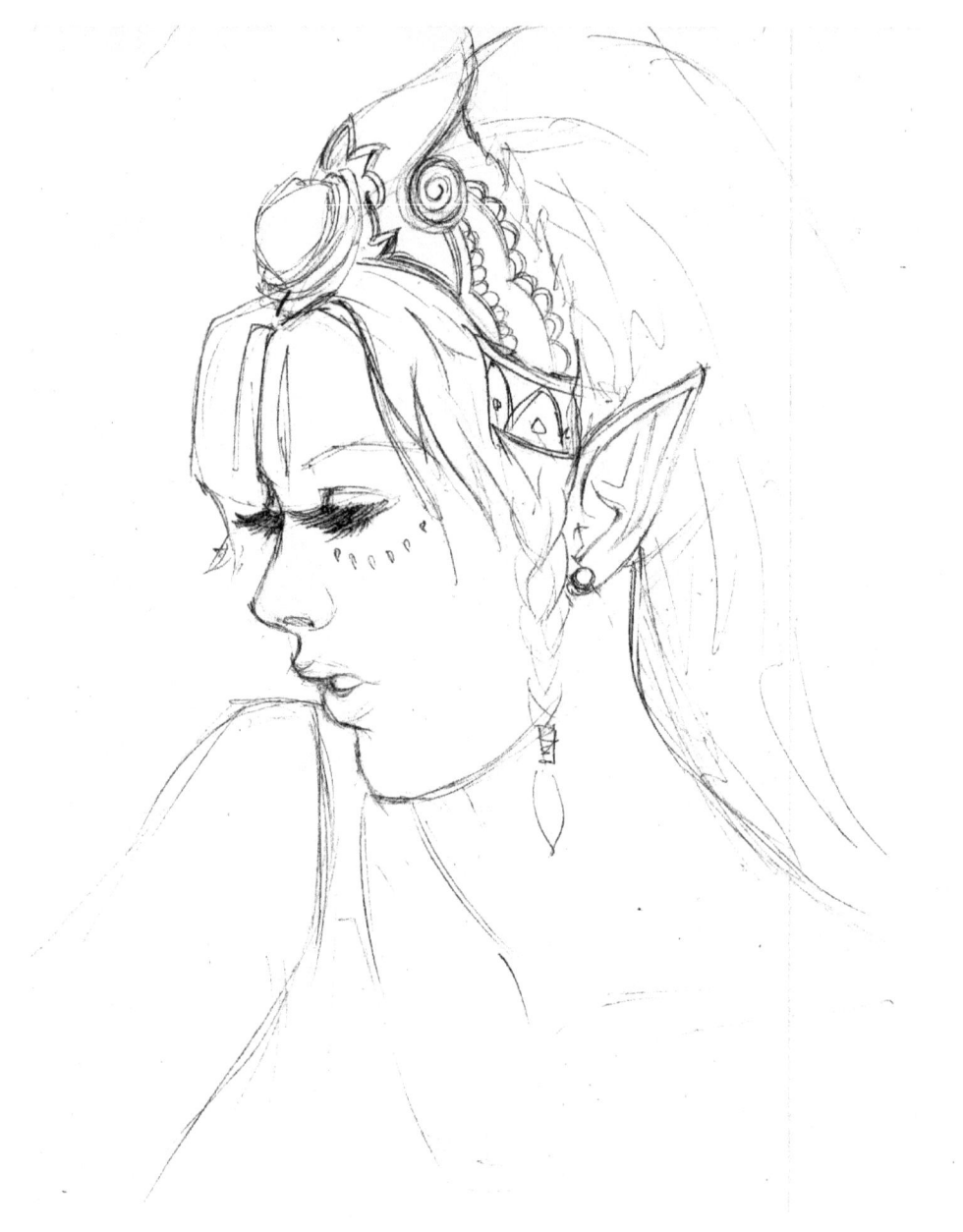

Make the lines of the face thicker, as well as the ears.

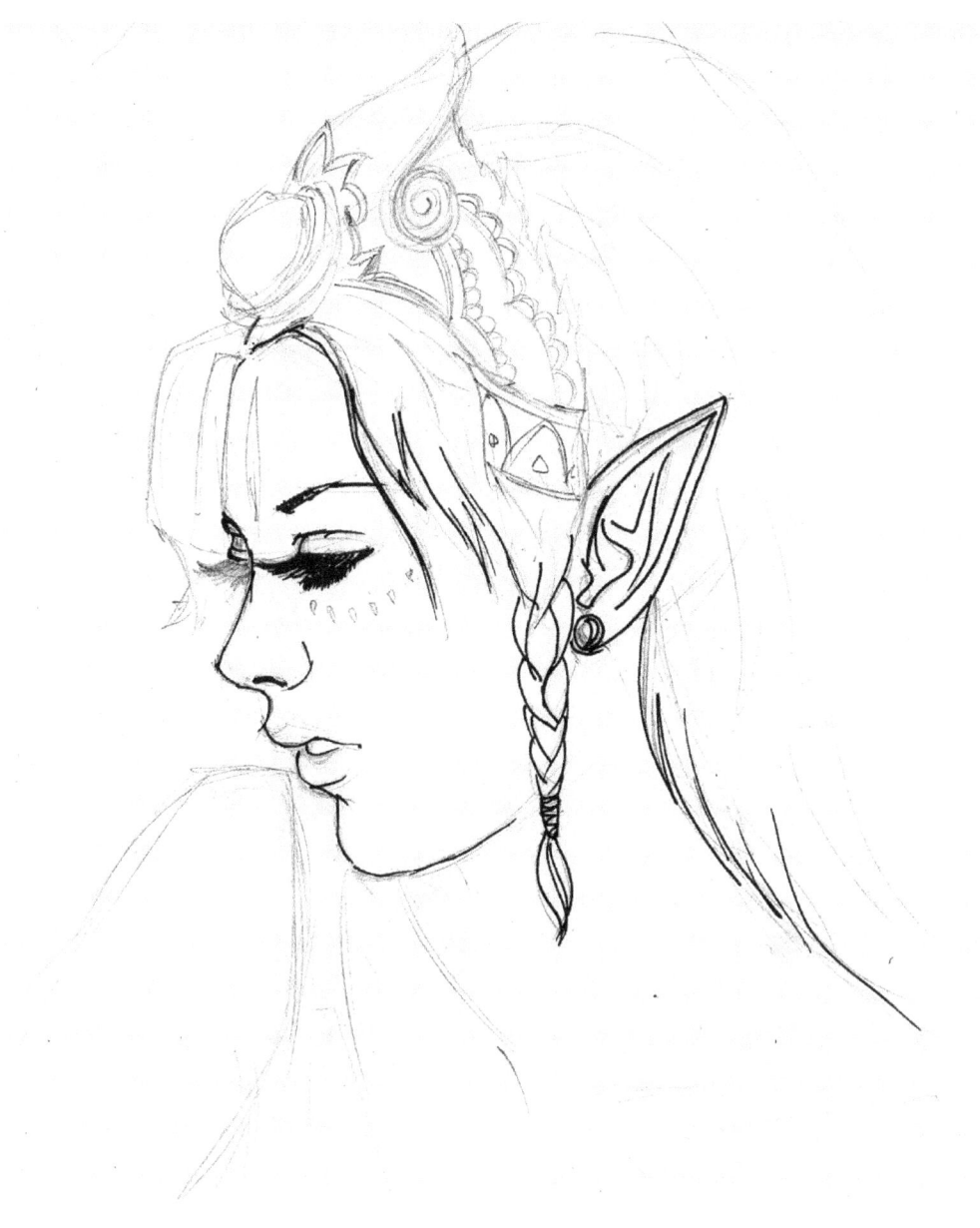

The final step is to make all of the lines thicker. Now you have it – the drawing of a beautiful female elf. Still, you can let your mind go and draw the lady elf your own way. Remember, elves are thought to be the most

beautiful creatures ever, so try to draw them beautiful. You can add more features to the drawing like piercings and more earrings if you want to.

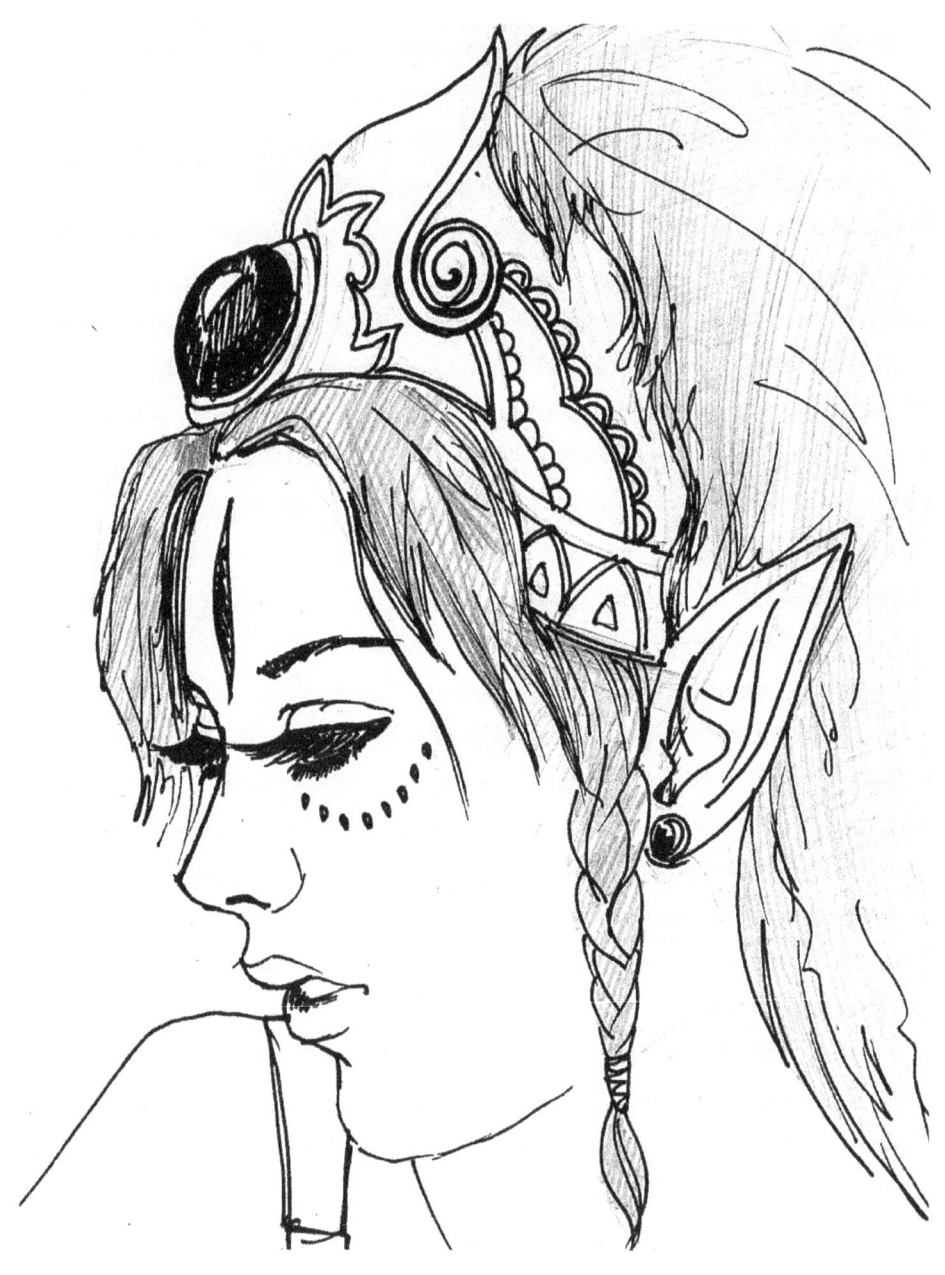

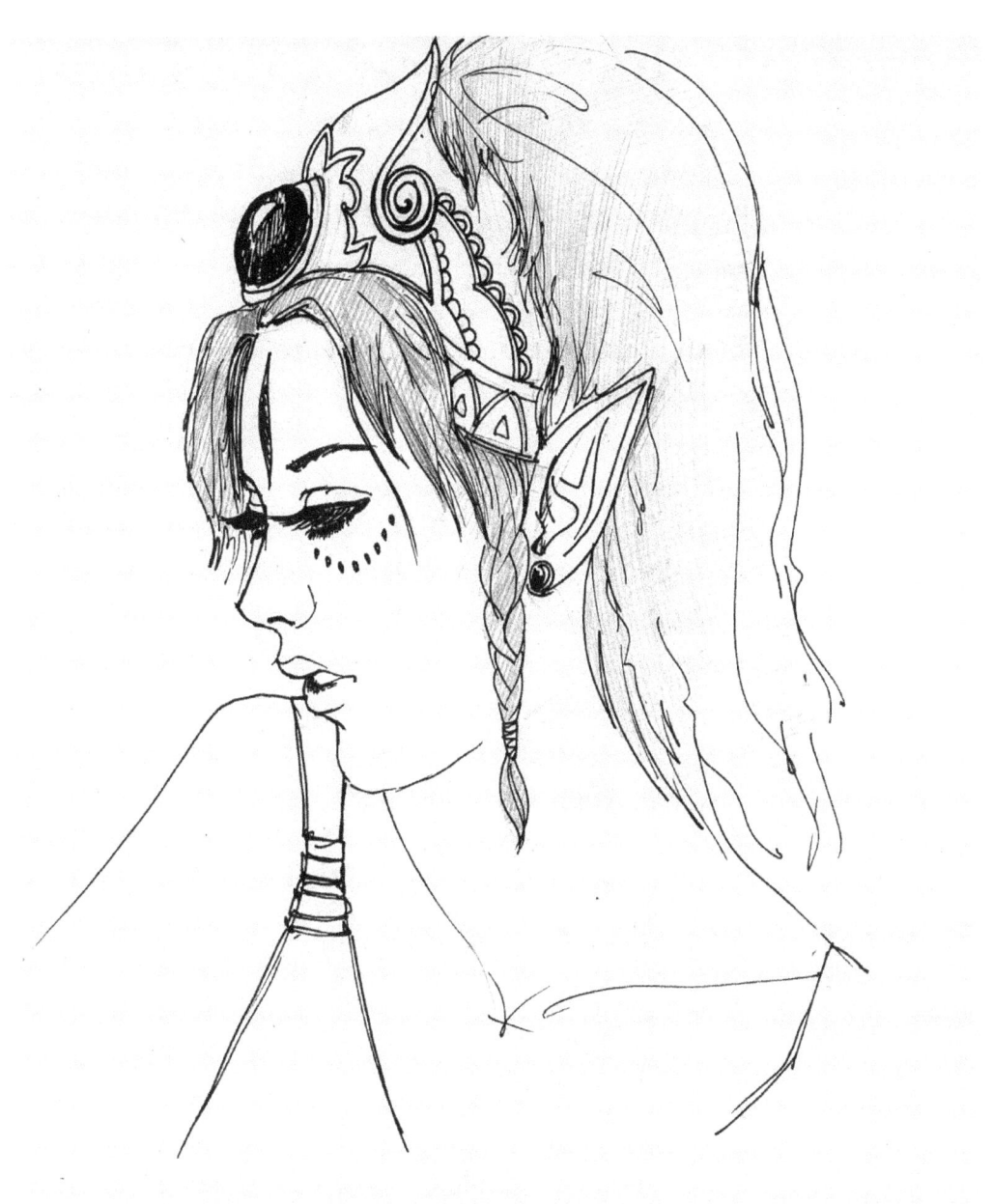

Chapter 4 – How to Draw a Mermaid?

Mermaid is a mythic creature that is half female human half a fish. The head and the upper body of the mermaid is of human, while the lower part is the tail of the fish. The myth of the mermaid has been around since the ancient days. It is not certain which culture first developed this myth as the evidence of mermaid stories can be found all over the world. The first recorded story about a mermaid comes from the ancient Assyria.

Mermaids are sometimes presented as benevolent creatures, while sometimes they are maleficent. For example, in Homer's Odyssey, mermaids or sirens are evil. On the other hand, the mermaid in Hans Christian Andersen's fairy tale "The Little Mermaid" from 1836 has a heart of gold.

Usually, in visual art, mermaids are depicted as beautiful women. There are thousands of paintings with mermaids in focal point as these creatures were the inspiration for artists from the ancient times to the modern era. Some of the most famous paintings and sculptures are of mermaids. You are probably familiar with Disney's version of this fantasy creature and in the

next part, we are going to teach you how to draw a beautiful mermaid in just four easy steps.

The first step is to draw three objects – a circle for the head of the mermaid, a half circle for the body and an eclipse for the mermaid's behind.

The next step is to draw the whole contour of the mermaid, from the head to the tail.

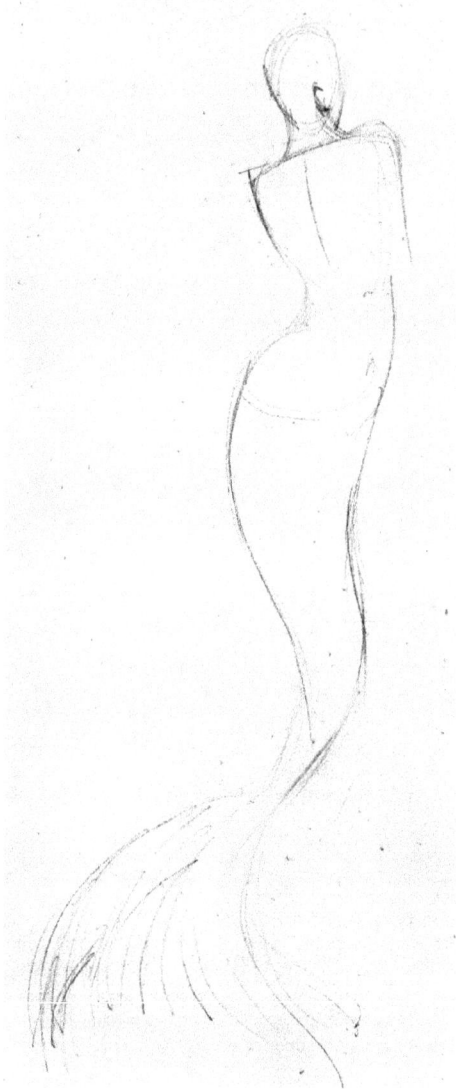

Add more details to the drawing of the mermaid, like the hair for example.

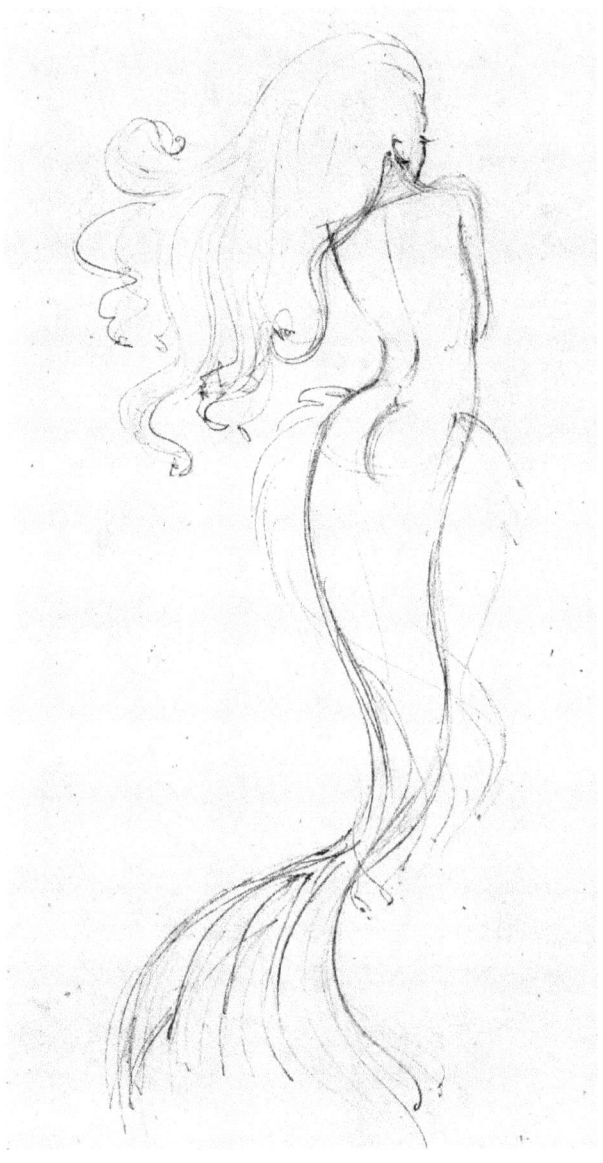

The final step is to make all of the lines thicker. In the final version, the face of the mermaid is not seen as she is facing the other way. But, if you wish you can draw the face of a beautiful woman.

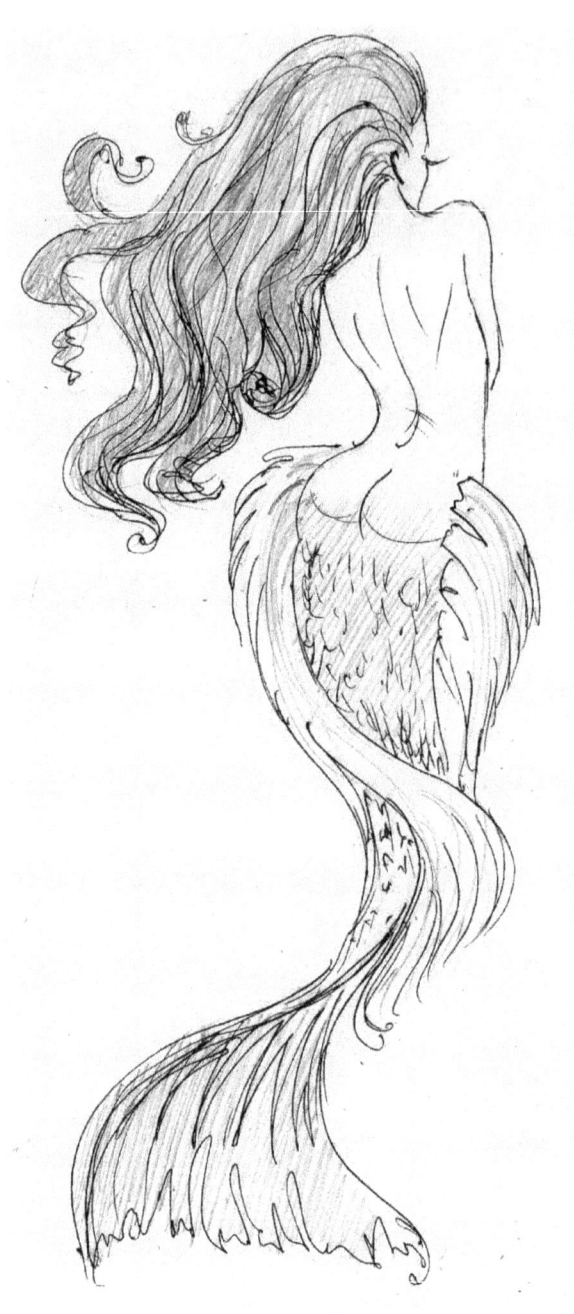

Chapter 5 – How to Draw a Gnome?

Gnomes are fictional creatures that often appear in fantasy novels. Most often they are small creatures that live on or in the ground. They are often identified with garden dwarfs, but they are often imagined as a small bearded little wizard in men's clothes.

In the trilogy Lord of the Rings they are presented as benign shy creations living underground. According to Tolkien, they are great mechanics and engineers. They create many machines. Their main vehicles are mechanical walkers. Their city was destroyed by the underground monsters and since then, they live together with the dwarfs.

They are also appearing in the Harry Potter novels of J. K. Rowling, who presented them as small dumb creatures with brownish skin and head shaped like potatoes, which live in large gardens. They usually live in groups and do not have magical abilities. Rowling mentioned the process of de-notification, i.e., cleaning the gardens of the gnomes. That's done by taking gnome and hurling it far away, so it won't know how to go back to the garden. That should be done quickly because otherwise gnome can bite the person throwing it.

Gnomes are fairly easy to draw, but only if you know how. So, carefully read the next part, in which we will show you how to draw a gnome.

Draw three simple objects, a big circle in the middle for the head of the gnome and two elliptical objects for its legs.

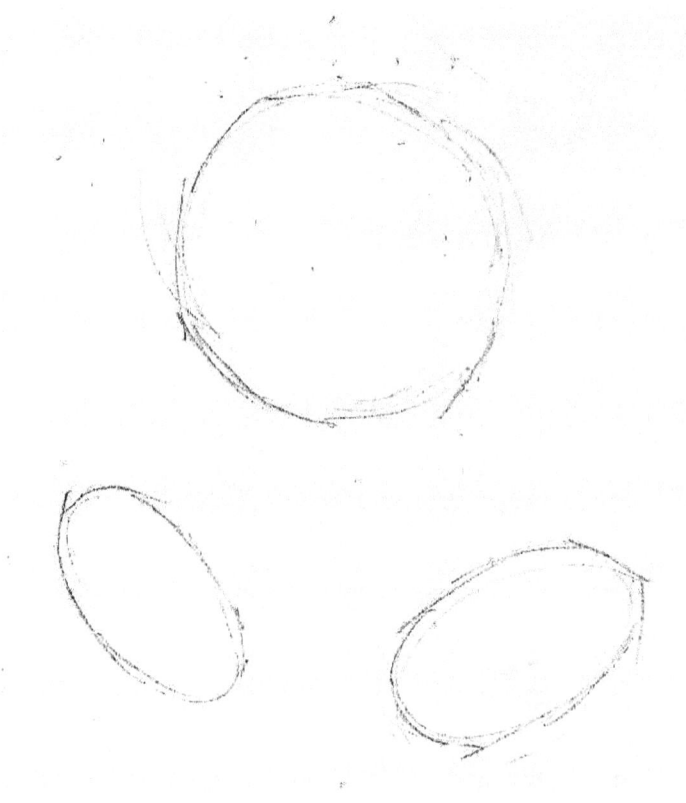

Add face features, like the eyes, nose and the mouth. In this step, you should also draw the toy that the gnome is holding.

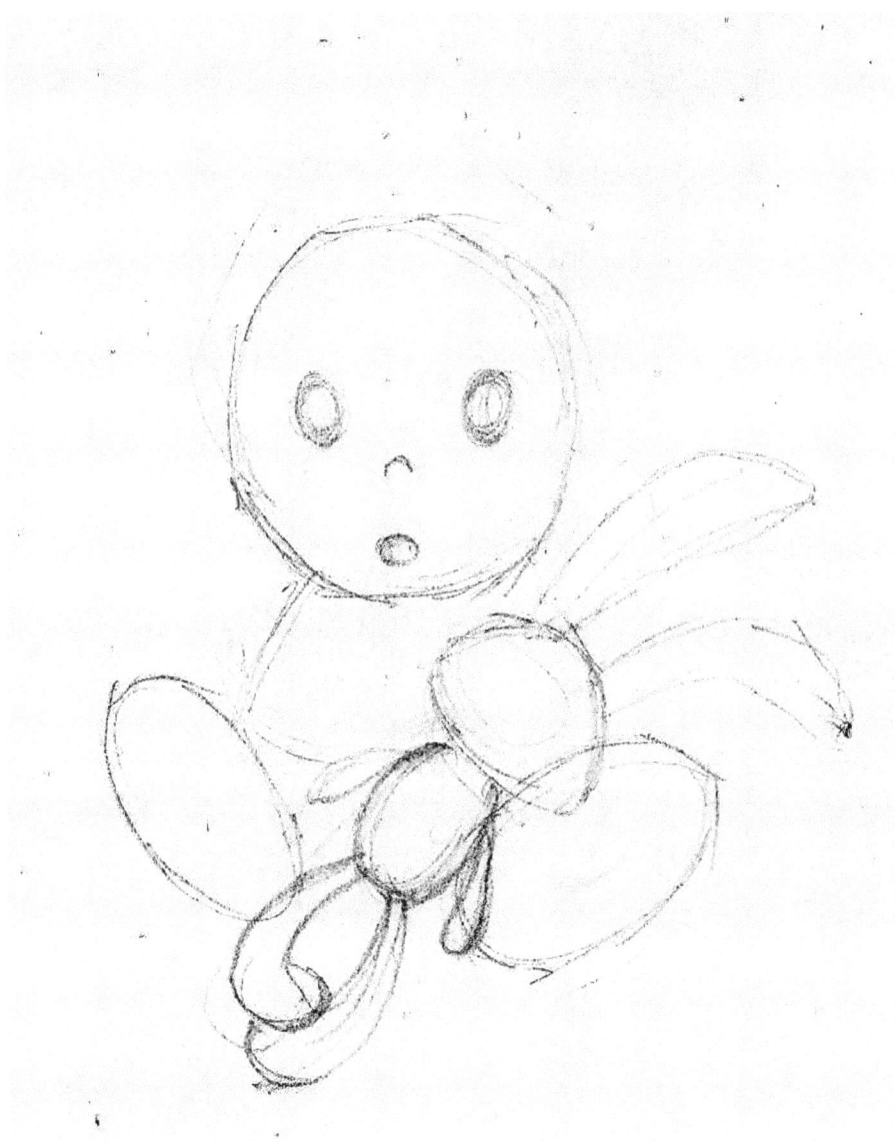

Draw the hair of the gnome, as well as the hair, while making bolder the lines that make the face features.

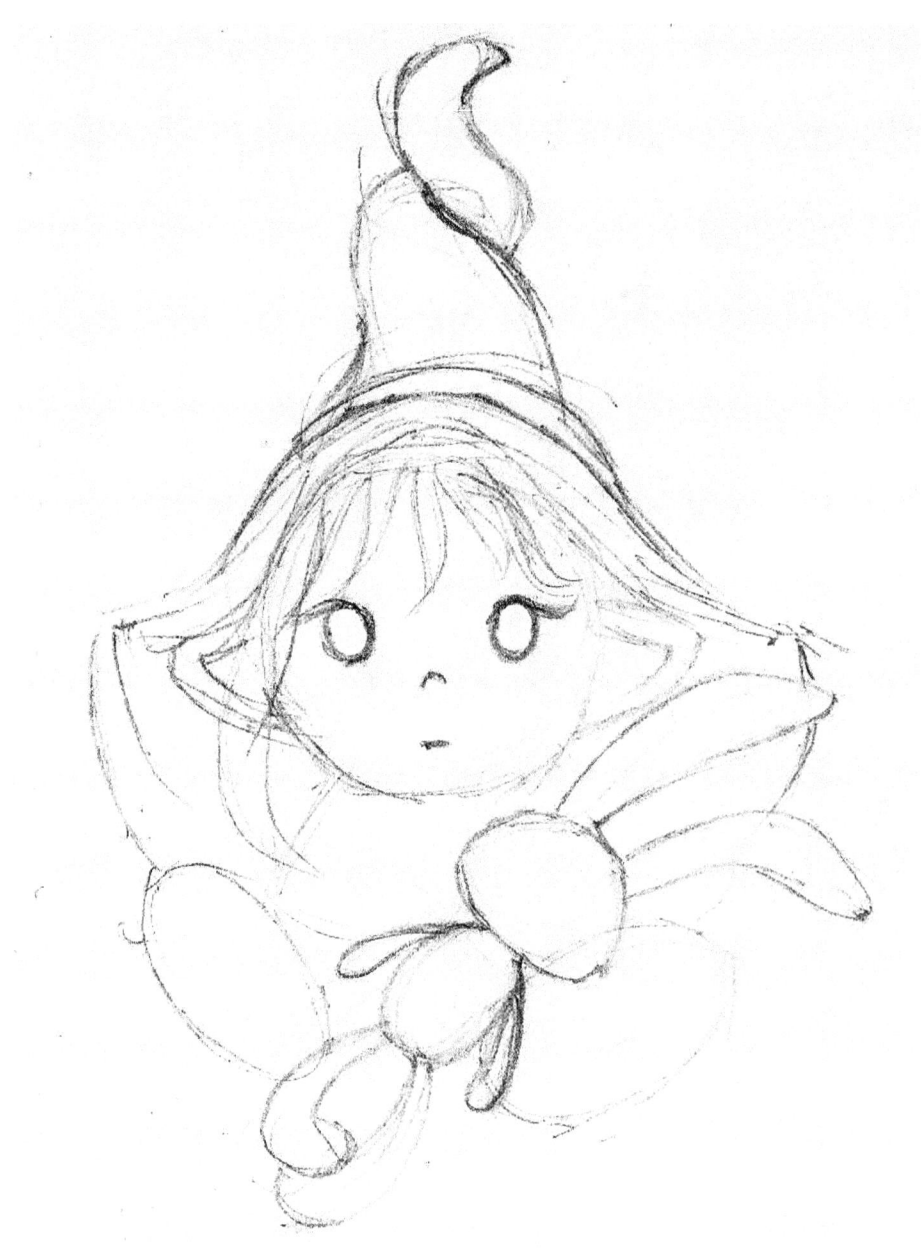

Add all of the remaining details, like the features of the toy. Also finish with hat and the hair.

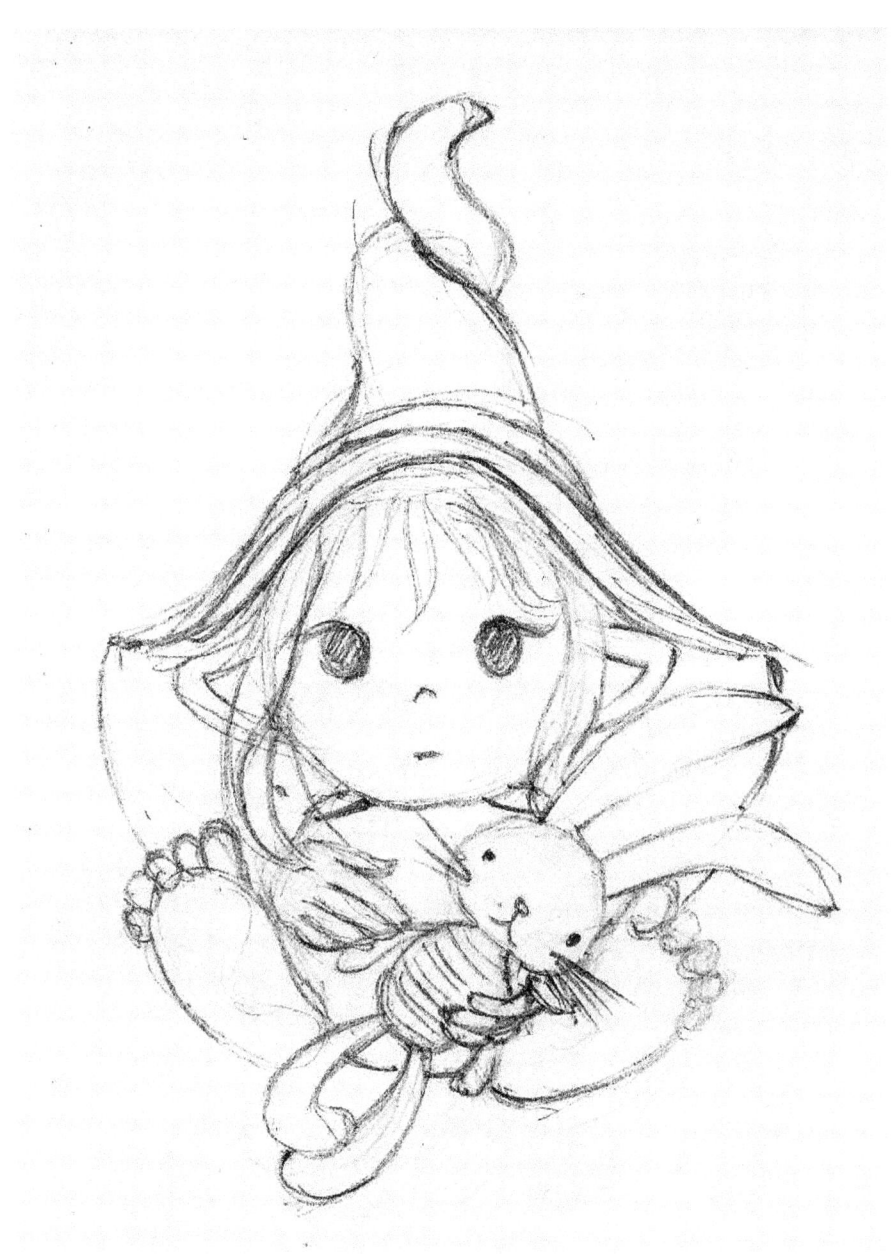

Finally, make all the lines more thick. You should get a cute drawing of a baby gnome. The final drawing should make you feel sympathetic, but it's

only our suggestion. If you wish, you can make the little gnome look evil. It's totally up to you.

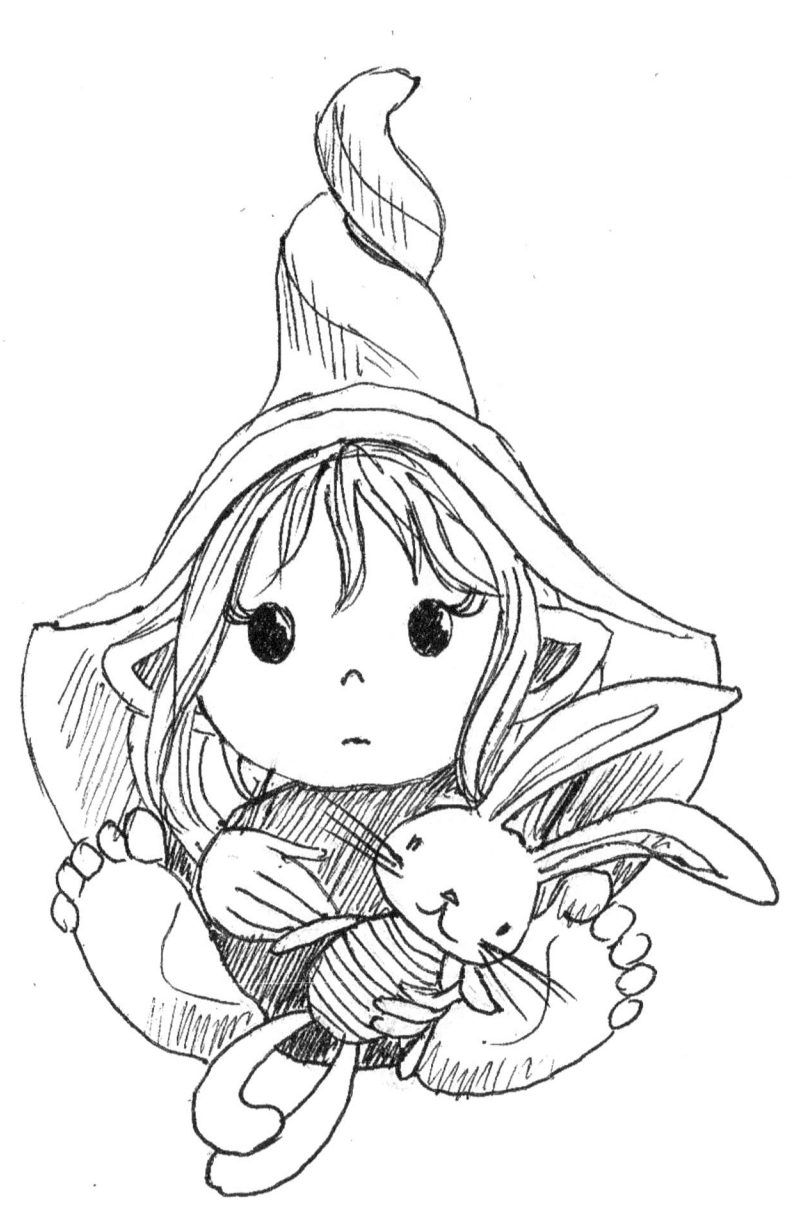

Chapter 6 – How to Draw a Lady Centaur?

Centaurs were mythical people, half man half horse, who lived in Thessaly. With few exceptions they were wild creatures, hostile to humans. The oldest myths do not say anything about their origin. The poet Pindar claimed that the father of the first centaur was a man named Centaur, who was allegedly the son of the King Ixion and Daphne, the incarnation of clouds. The young generation of centaurs lost its rawness and wildness and joined the satyrs accompanied by the god Dionysus.

Centaurs in the ancient mythology could be either male or female. The female version of the centaur is called the centaurs. Centauries can be found in lots of ancient Greek art pieces and Roman mosaics. Later, female centaurs draw inspiration of artists in renaissance, but also in the 20th century.

If you want to learn how to draw a lady centaur, keep close attention to the next part.

You start drawing centaurs by drawing objects that would become its head and the body.

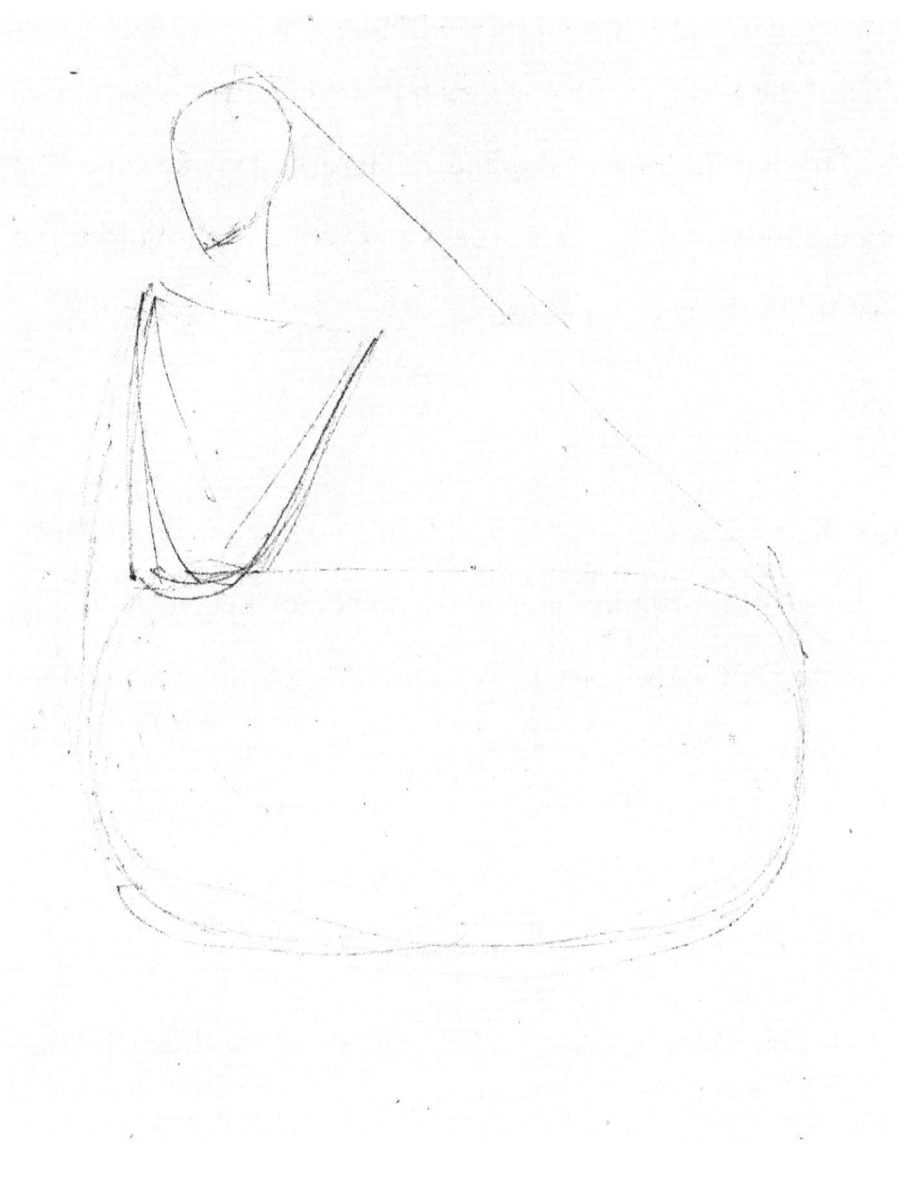

Add more lines to do the body of the centaurs.

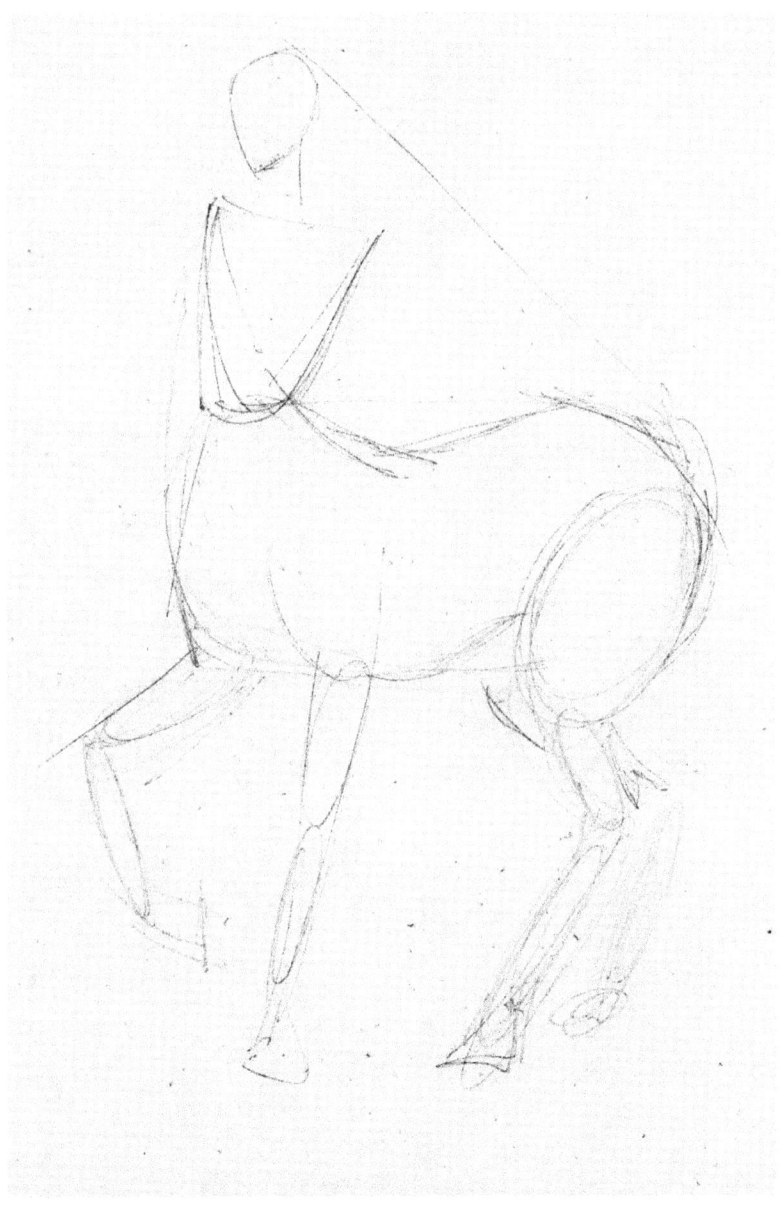

Add more details to the upper body of the creature. Draw the breasts and the hands of the female human part of the being.

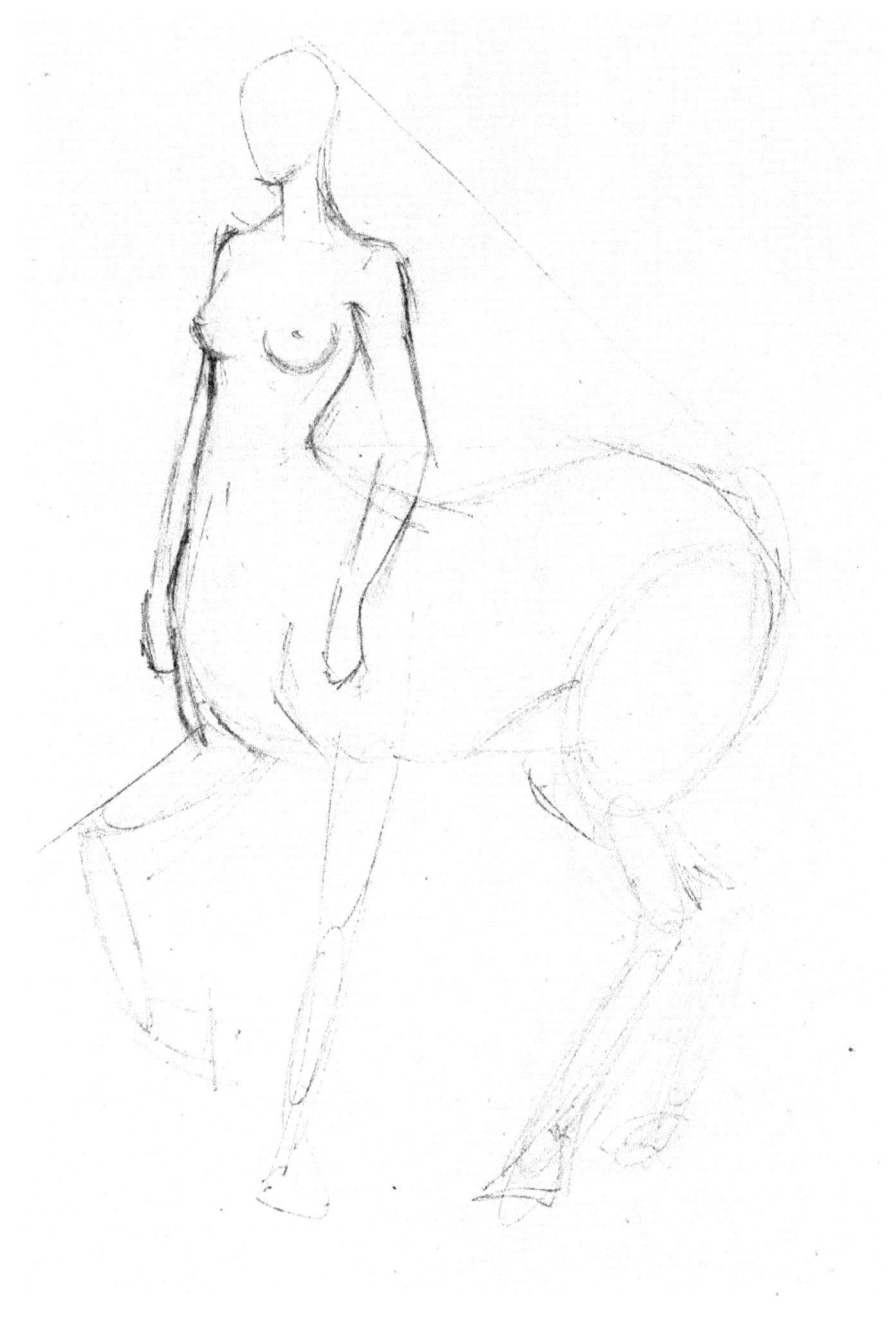

Make the lines thicker which make the legs and the lower part of the creature's body.

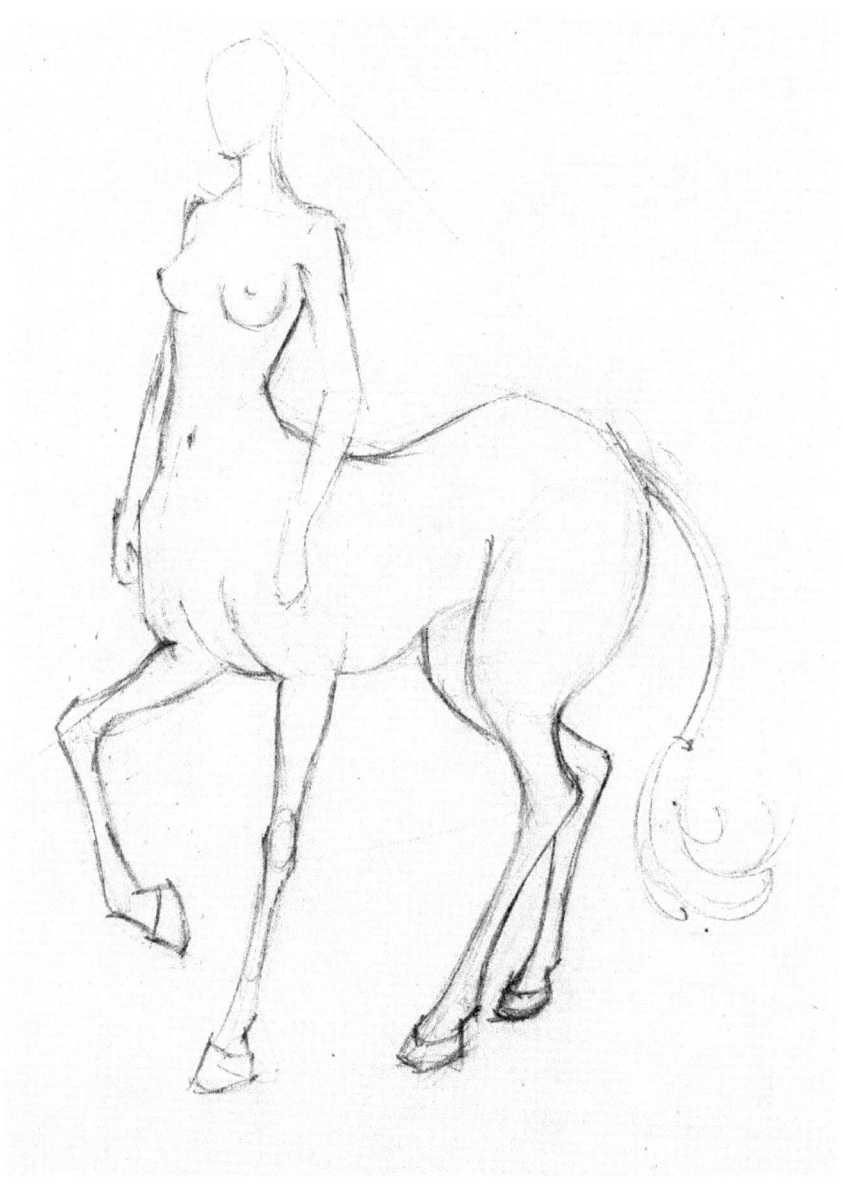

Add details to the head, like the horn and the hair. Also, make lines of the tail more thick.

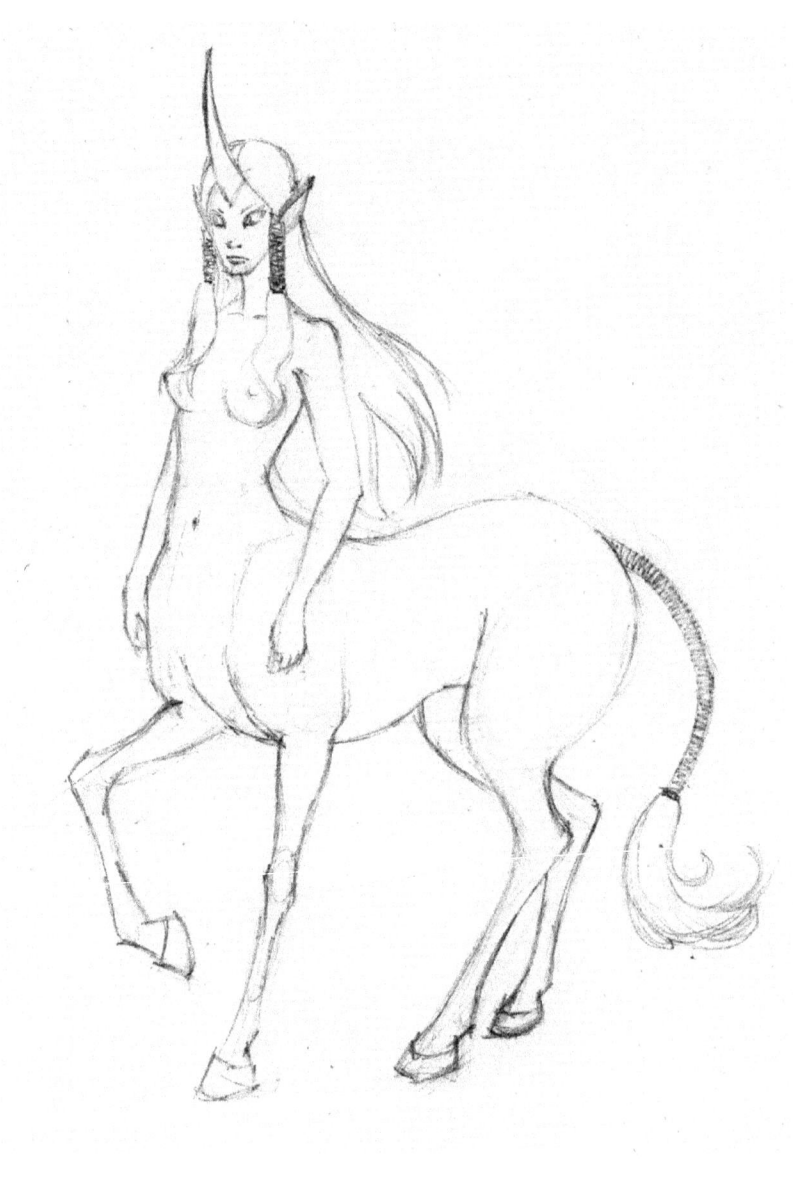

This is how the final drawing should look like. You should get the drawing of a lady centaur with beautiful face of a woman and strong muscular body of a horse.

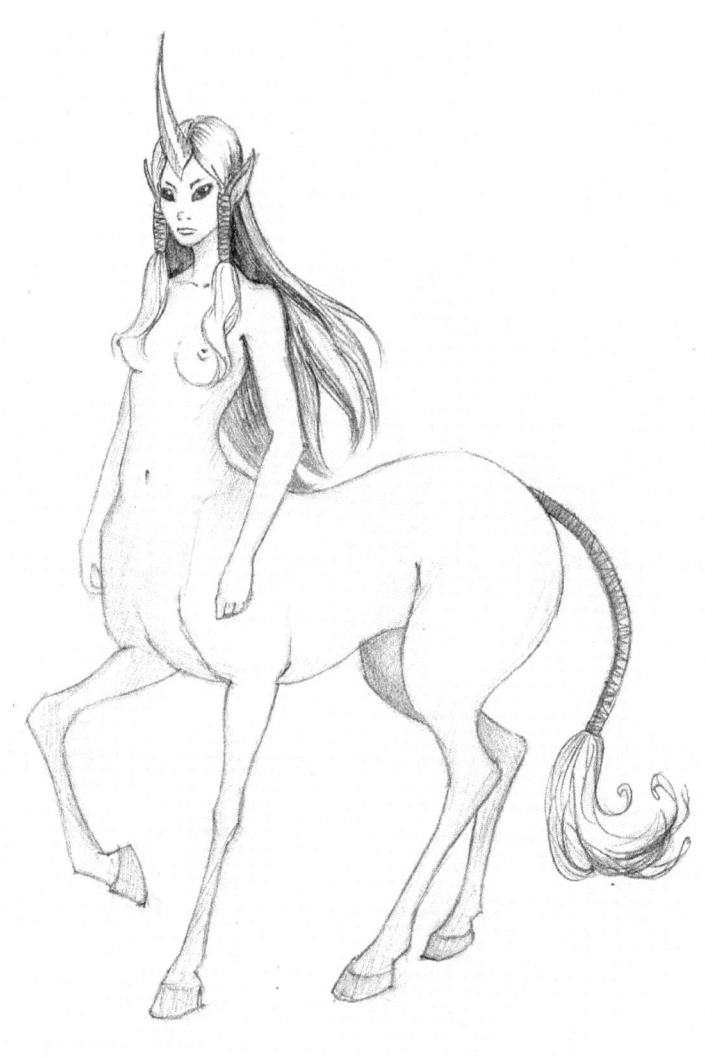

Conclusion

Dear reader, congratulations on finishing the book. Now, you are familiar with the ways of easy drawing the drawings of several different mythical beings, but not only that, if you read the short story about every of the creatures, you learn about where they're coming from and what people thought of them in the past.

Hopefully, you had fun reading the book as our goal wasn't simply to make you familiar with the techniques about how to draw mythical creatures; we also wanted to make the reading fun by talking about each being separately. Our reasoning was that if you get to know these fantasy creatures better, you will fall in love with them. And once you love them, you will be more enthusiastic about drawing them.

Remember, after reading this book, you have learned the basics of drawing the mythical figures. But, this is just the beginning. If you wish to be successful in drawing or simply improve a bit, you must not quit doing it on regular basis. Practice is the only way that turns an amateur into a pro.

So why should you keep on drawing even when you're done reading the book? Well, apart from it's awesome to draw mythical creatures like elves and centaurs; it is also very good for you. Drawing sets your mind free and makes you relaxed. This is a great hobby to forget about all of your everyday problems and let it go. Once you get into the state of flow, the only thing that will be on your mind is drawing.

Thank you!

Thank you for choosing our book, we hope you found it interesting and helpful.

If you liked the book, please give us a favor to write your review.

We would really appreciate this!

If you would like to have a bonus – **FREE BOOK**, please send the screenshot of your review to this e-mail: kelly.artbooks@gmail.com and we will send you a **FREE BOOK** in PDF as a **GIFT!****

Hope to see you in our future books and good luck in your drawing experience!

**** in the e-mail subject please mention the name of the book you reviewed and the author.**

www.ingramcontent.com/pod-product-compliance
Lightning Source LLC
Chambersburg PA
CBHW080550190526
45169CB00007B/2708